Landscape Confection

Landscape Confection

Helen Molesworth

Wexner Center for the Arts | The Ohio State University

Published in association
with *Landscape Confection*

Organized by
Wexner Center for the Arts
The Ohio State University
Columbus, Ohio
Curator: Helen Molesworth

On view at
Wexner Center Galleries
at The Belmont Building
330 West Spring Street
Columbus, Ohio 43215
January 29–May 1, 2005

Contemporary Arts Museum Houston
5216 Montrose Blvd.
Houston, Texas 77006
July 23–September 11, 2005

Orange County Museum of Art
850 San Clemente Drive
Newport Beach, California 92660
February 5–May 7, 2006

Major support for *Landscape
Confection* was provided by
Univar USA, The Scotts Company,
and Nancy and David Gill.

Additional support was provided
by Glavan Fehér Architects, the
National Endowment for the Arts,
and the Corporate Annual Fund
of the Wexner Center Foundation.

Accommodations in Columbus
were provided by The Blackwell Inn.

Promotional support in Columbus
was provided by WBNS 10TV.

Curatorial Assistants
Katherine Whitlock
Megan Cavanaugh Novak

Graphic Designer
M. Christopher Jones

Editor
Ann Bremner

© 2005 Wexner Center for the Arts
The Ohio State University

Published by
Wexner Center for the Arts
The Ohio State University
1871 North High Street
Columbus, Ohio 43210-1393
USA
Tel: +614-292-0330
Fax: +614-292-3369
www.wexarts.org

Distributed by
D.A.P. Distributed Art Publishers, Inc.
155 Sixth Avenue, 2nd Floor
New York, New York 10013
Tel: +212-627-1999 / +800-338-2665
Fax: +212-627-9484
www.artbook.com

ISBN: 1-881390-36-5

Library of Congress Control Number:
2004115912

Contents

Lenders to the Exhibition

Collection of Anne Baldwin and Michael Monti
The Baltimore Museum of Art
CAP Collection
Collection of Janice and Mickey Cartin
Collection of Ramesh Chakrapani, New York
Collection of David Edmondson
Collection of Dave and Nancy Gill, Columbus, Ohio
Francie Bishop Good, Ft. Lauderdale, Florida
Susan Hancock and Ray Otis, Winter Park, Florida
Mr. and Mrs. C. Robert Kidder, Columbus, Ohio
Collection of Jon Koplovitz, New York
Lindemann Collection, Miami Beach
Jennifer McSweeney and Peter Reuss
Collections of Eileen Harris-Norton and Peter Norton, Santa Monica
Ron and Ann Pizzuti, Columbus, Ohio
Rubell Family Collection, Miami
Collection of Ellen and Peter Safir
Sender Collection
Collection Steve Shane, New York
Amy Sillman
Sprint Corporation Art Collection, Overland Park, Kansas
Rebecca and Alexander Stewart, Seattle, Washington
Marc and Livia Strauss Family Collection, Chappaqua, New York
Collection of Andres Tremols and Michael Reamy
Collection of Dean Valentine and Amy Adelson, Los Angeles
Collection Van Valen, New York/Amsterdam
Whitney Museum of American Art, New York
Private collections

Director's Foreword

Even as the list of artistic ingredients was yet in formation and the precise recipe in flux, there was something irresistible cooking in Helen Molesworth's curatorial kitchen as she concocted the exhibition *Landscape Confection*. The mere title conjured delectable imagery of all kinds while harboring subtle underlying flavors, as all truly exquisite culinary moments do. Aside from the promise of sweet, scrumptious delights, it offered just that dash of spun sugar that dazzles the eye as it teases the taste buds and quickens the metabolism, then melts away into gustatory memory, no less potent for its inevitable dissolution.

So too the title offered vistas of stunning imagination. After all, the term "landscape" is often defined as scenery, with all the theatrical connotations of a backdrop. And "confection" of course suggests no ordinary morsel, but rather an elaborately ornamented one whose shimmering shell may well conceal an unexpected center. Thus, Helen sets the table for a sumptuous buffet of paintings you consume at your pleasure and your peril, with not an empty calorie among them.

While the first taste of this exhibition arose in the hothouse of flavors that is Miami Beach, it is by no means confined to images of tropical paradise. *Landscape Confection* draws on creative ecosystems as various as London and Los Angeles, New York and Rio, Düsseldorf and Bangalore. It offers a liberal portion of gloom along with glitter, and swoon along with shiver. If, as Helen notes in her redolent essay for this catalogue, one artist summons the determined energy and airiness of de Kooning and Mrs. Dalloway, others emerge from the creepy depths of David Lynch or Freddy Krueger. The classic eighteenth-century landscape meets its twenty-first-century progeny as the not-so-innocent frolic of the *fête galante* morphs into a ghastly dance atop the toxic waste dump. Not that all contemporary landscapes are

ominous, mind you. Some are positively fecund in their ecstatic abundance, while others find Dickinson-like poetry in their fierce solitude and economy of means.

With *Landscape Confection*, Helen posits a particular set of prisms through which artists today seize the hallowed tradition of pastoral painting and make it relevant to the vastly changed terrain of our time. She rightfully cites the enormity of modernity's cultural struggle with the decorative, the overwrought, the pathetically petit-bourgeois. No wonder the genre of landscape painting was imperiled. And as with other epochal battles, it is often only a few generations later when notions once emphatically discarded are resurrected for fresh interpretation and use (or further abuse). So it is that the thirteen artists in the exhibition variously draw upon a pluralistic palette of materials, referents, and sensibilities to confect their creations.

It is in fact the heterogeneity of their enterprise that convinces us to pay attention. Had the emergent energy of contemporary landscape primarily derived from sheerly pictorial or stylistic concerns, it would not have appealed to Helen's visual and critical receptors in the same way. Rather she detected something of deeper and more pervasive force that bore examination. It is precisely this capacity for divining contemporary cultural patterns that makes her such an asset to the Wexner Center and to the field. I am pleased to recognize that special talent and to thank her for bringing it into our midst. I also join Helen in expressing appreciation to Claudine Isé for her excellent contributions to this catalogue, and to the curatorial discourse at the center generally.

In addition to those immediate members of the exhibition team that Helen acknowledges in this volume, I would like to add my thanks to Joan Hendricks and Pug Heller for their attention to the details of registration and exhibition installation. Ann Bremner, in customary fashion, brought intelligence and precision to all matters editorial, while Chris Jones crafted a decorous (though not merely decorative) look for this catalogue and the exhibition graphics.

As ever, the center's education team organized an array of complementary events to further explore the fertile issues raised by the exhibition, while the communications department brought *Landscape Confection* to the attention of wider audiences through a plethora of media. My thanks as well to the many unsung staff members throughout the center who make our artistic presentations possible from every conceivable angle.

The Wexner Center development team, led by Jeffrey Byars, harnessed a diverse array of resources to support the exhibition, catalogue, and related events, and it is my pleasure

to recognize their generosity here. We are especially grateful to Univar USA, The Scotts Company, and Nancy and Dave Gill, all of whom provided significant support to the exhibition. Additional funding was received from Glavan Fehér Architects, the National Endowment for the Arts, and the Corporate Annual Fund of the Wexner Center Foundation. We are also pleased to have enlisted valuable in-kind support from The Blackwell Inn and WBNS 10TV.

I reserve my utmost thanks for the artists participating in the exhibition, and for the individual and institutional lenders who have so graciously shared their work with us. We are delighted that *Landscape Confection* will travel on from Columbus to other locales, first to Houston, and then to Newport Beach. It is a pleasure to collaborate once again with Director Marti Mayo and Associate Curator Valerie Cassel Oliver at the Contemporary Arts Museum Houston. And we welcome the participation of the Orange County Museum of Art, under the leadership of Director Dennis Szakacs and Deputy Director for Programs and Chief Curator Elizabeth Armstrong.

I am reminded that upon first hearing the proposed title of the exhibition, my immediate—shamefully uncensored—thought was of paintings you want to lick. Casting aside this shockingly inappropriate mental image (especially for a veteran museum official!), I serve up the appealing notion of art as a potent comestible for human sustenance.

Sherri Geldin

Landscape Confection:
The Loneliness of the Decorative

Helen Molesworth

To fill a Gap
Insert the Thing that caused it—
Block it up
With Other—and 'twill yawn the more—
You cannot solder an Abyss
With Air.

Emily Dickinson c. 1862

Twentieth-century painting has had a love-hate affair with the notion of the decorative since its inception. Cubists Pablo Picasso and Georges Braque, along with their compatriots Albert Gleizes and Jean Metzinger, were adamant in their refusal of the decorative, and they purged their early canvases of excess color, paring them down to a dull conflation of gray and brown. Their desire was to ward off any viewer in search of a visual titillation not bound exclusively to the more intellectual pleasures of negotiating the new picture planes offered by cubism. And yet it was Picasso and Braque, this time in league with Juan Gris, who also included strips of printed wallpaper in delicate constructions. In these collages the distinction between the flatness of the picture and the flatness of the wall nearly dissolved in a confusion engendered in part by the explicitly decorative quality of early-twentieth-century printed wallpaper.[1] Anxiety about the decorative took place across twentieth-century modernist production. Its apotheosis as a trope of modernism can be found in Adolf Loos's nearly panic-stricken account in "Ornament and Crime" (1908). Loos vociferously argued that ornament was a fundamentally primitive urge, something modern societies needed to leave behind, going so far as to say, "The evolution of culture is synonymous with the removal of ornament from utilitarian objects."[2] Loos mapped his suspicion of the decorative onto a larger fear of things primitive, exotic, and feminine. He was not alone in these conflations, and the association of the decorative with the feminine is a strong one.

The tension between serious, autonomous, and *avant-garde* painting and decorative painting destined to reside above the sofa played itself out repeatedly throughout the century. Painting vacillated between Matisse's desire to make art to be looked at from the relaxing

venue of a bourgeois armchair and Marcel Duchamp's desire to place art in the service of the mind. This kind of aesthetic debate continued with a vengeance with the rise of abstract expressionism. Here, all-over canvases, with no compositional hierarchy or narrative, aspired toward a purity of painterly aims—and the pursuit of complete nonillusionism was seen to be nothing short of the attainment of the ontological truth of painting. Yet despite the hugely ambitious aims of such artists (and their critics), there was a relative ease to the way the paintings migrated out of the studio and up onto the walls of bourgeois homes. One is haunted by the glimmering fashion photographs of Cecil Beaton, who had luxuriously posed well-heeled models in front of Pollock's *Number I* and *Autumn Rhythm* as early as 1950. What a dilemma to see such paintings so quickly transformed into lush, tangled backdrops for high society evening dresses.[3] And yet the paintings' "transformation" is, of course, at the heart of the matter, for suppose they were merely decorative backdrops all along? This was what worried Clement Greenberg, "who saw the main danger for the abstract artist as that of becoming a mere 'decorator'." But Greenberg shied from a blanket condemnation of the decorative in order to preserve a relationship to the work of Henri Matisse. "'True decorativeness' in Matisse's work…could be expressive; and being expressive meant overcoming 'mere decorativeness'."[4] The "merely decorative" constituted the major threat for abstract painting, a threat historically associated with the "problem" of the feminine. Given the terms of the playing field, it is perhaps no surprise that painterly abstraction ended up being aligned with a kind of muscular, masculine, heroism. The rub is that the painting that wanted most to avoid being "merely decorative" was, of course, the painting that most ran the risk of it.

Perhaps nothing in this review of modernism's fear and loathing of the decorative should come as much of a surprise. What is curious is a recent spate of painting, at the beginning of the twenty-first century, which embraces the decorative *tout court*. Contemporary artists do not find the pursuit of serious painting and the decorative to be incommensurate, and they avowedly, markedly, and fiercely even, do not find in the decorative, the artificial, and ornament any sense of threat. Indeed, if the decorative is aligned with an idea of the feminine, here the feminine is seen as a set of strategies equally available to artists of both genders. The artists in *Landscape Confection* pursue the decorative across numerous fronts. Far from trying to purge painting of influences and ideas not exclusive to the medium as such, these artists revel in painting's newfound heterogeneity. Many of the paintings derive from the unconscious space of dreams, some borrow from

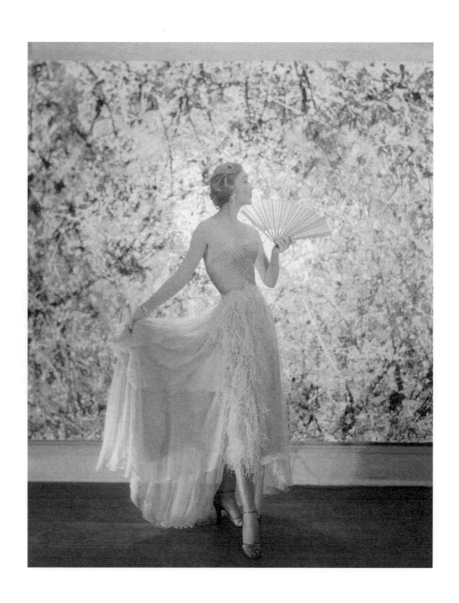

Cecil Beaton
British, 1904–1980
Model in front of *Number 1* (Jackson Pollock painting), 1950
Photograph in *Vogue*, March 1. 1951

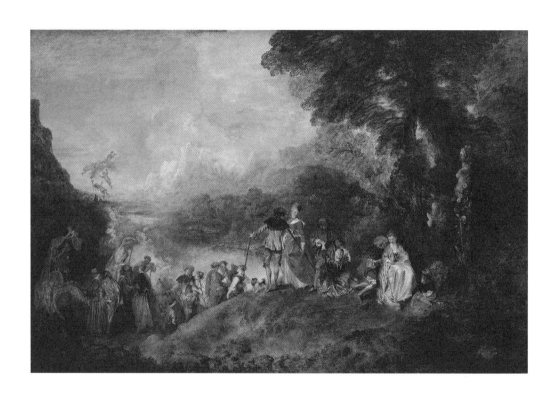

Jean-Antoine Watteau
French, 1684–1721
L'embarquement pour Cythere (The Embarkation for Cythera), 1717
Oil on canvas
50¾ x 76⅜ in. (129 x 194 cm)
Louvre, Paris, France

the discipline of topography, and still others reside at the boundary between landscape and abstraction. Most of the pictures have a high degree of whimsy, and they call to mind the *fête galantes* of Jean-Antoine Watteau, as they are redolent with bodily and visual pleasure. Hence these fantastical landscapes explore the natural world as perceived through an array of mediations as disparate as impressionism, naturalist illustrations, Hanna-Barbera animation, *New Yorker* cartoons, abstract expressionism, feminist art, and decorative wallpaper patterns. This current embrace of the artificial has provoked a gleeful palette that includes the previously denigrated pastel, candy-coated, putatively kitschy, or saccharine, seeing instead in such colors the land of fantasy and dreamscape, pleasure and possibility.

And yet perhaps not everything is whimsy and roses, perfume and light. For in much of the work there is a tinge of the melancholic. As much as the palette of Amy Sillman's *Valentine's Day* or *The Egyptians* calls to mind either the tranquility of the Gulf of Mexico or the riotous blooms of a late summer garden, in each painting there is a distinct sense of alienation. In *The Egyptians* anthropomorphic stick figures exchange gifts over a sea of small creatures, but they do so stiffly, ceremoniously, and joylessly, as if staging the desire for community and its impossibility simultaneously. In *Valentine's Day* the aqueous world seems to come unzipped and contain within it a disk of swirled emotions. However comfortable these paintings may appear to be with a "decorative" endpoint above the sofa (there is no *épater le bourgeois* here), they contain within them a charge of emotion, a kind of inchoate, unconscious energy that nonetheless rings palpably throughout the viewing experience. These paintings are saturated with what Freud might describe as a kind of everyday, reasonable unhappiness.

The loneliness of these works is perhaps somewhat counterintuitive, especially given the light-hearted emotion carried by the profusion of color found in them. Such feelings are clearer in Michael Raedecker's landscape paintings. Deploying a similarly pastel palette, the works are composed through painstaking embroidery and sewing, such that the figure-ground relationship is often one of thread to paint. The paintings are nothing if not decorative in their double relation to the traditionally defined women's work of sewing and the genre of landscape painting. But despite what might be called their double embeddedness in the ornamental, Raedecker's works, for all of their visual delights, offer a consistently cinematic brand of emptiness: his landscapes remain unpopulated; they show spaces to be passed through, frozen moments in time.

Lisa Sanditz's paintings share a uniformly unpopulated quality, although unlike Raedecker's quasi-uncanny spaces her pictures are filled with a jumble of geometric planes. Candy-colored flat expanses of color and Diebenkornesque patches of sky tilt up toward the canvas, creating pictures that look as if they might topple off the canvas. In Sanditz's work the tension between abstraction and decoration is no longer held as a structuring dialectic, and even less is the gulf between them (or the razor's edge that separates them) seen to be a threat to the idea of "good painting." Sanditz paints the commercial and residential landscape of suburban America with all of its simultaneous drabness and its color-coded signifiers directing one to buy, eat, or sleep in the designated areas. She paints these transitory views as if from snapshots taken from a disposable camera out of the window of a moving car.

Jason Gubbiotti's work pushes the logic of the decorative into the very support structure of the painting. If modernist painting wanted to insist on its two-dimensionality, then Gubbiotti's work wants to embellish the support, making stretchers that bump off the hanging surface, bulge out of the frame, and wrap around the corner wall. Using what Claudine Isé has called the palette of "contemporary product design—ice blue, safety orange, and acid green,"[5] Gubbiotti draws parallels between abstract painting and computer imagery, contemporary product design, and suburban architecture. By combining radical abstraction with a decorative ground/structure/palette Gubbiotti disallows the traditional division between the abstract and the decorative. His undulating architectural canvases may even serve as segues between space—coyly moving the viewer from one domestic interior to another.

Many of the artists in *Landscape Confection* explicitly address domestic space through scale. They have rejected the mammoth (dare we say bombastic?) scale of museum-bound painting and have opted instead for more human scale, secure in the idea that these paintings are bound for domestic space. In each of their works the tension between abstraction and decoration is neither conflated, nor resolved, nor is it perceived to be a problem as such. Rather, Gubbiotti, Raedecker, Sanditz, and Sillman stage the history of the abstraction/decoration, museum/home, art/craft binaries as a generative engine for painting. It's a curious thing, this residual kernel of a problem, now dispersed across the picture planes of so many younger artists. Why, one wants to know, aren't they afraid of the decorative? Why do they not labor under the problem, but rather stage it anew in terms that now seem to vacillate between the carefree and the obsessive, emptiness and fullness, pleasure and loneliness?

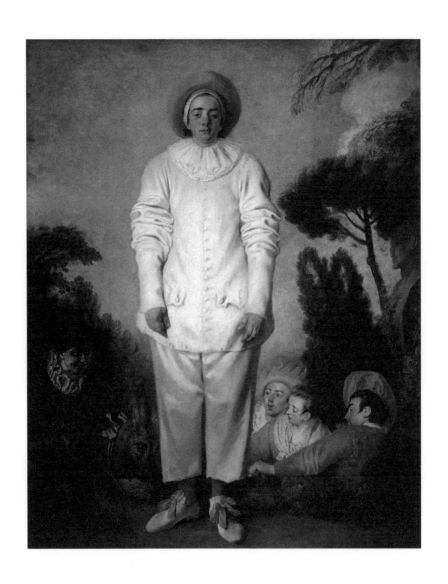

Jean-Antoine Watteau
French, 1684–1721
Gilles, c. 1718–19
Oil on canvas
72⅜ x 58⅞ in. (184.5 x 149.5 cm)
Louvre, Paris, France

I think the answers to these questions reside in a variety of places. One of the most interesting aspects of the work in *Landscape Confection* is the expansive field of influences and resonances the artists choose to work within. It is a field anchored by the extraordinary oeuvre of Watteau, the paintings of Willem de Kooning, and the radical nature of 1970s' American feminist practice. This triangle offers a wholly different relationship to the decorative as both a trope and a practice. The very proximity of such counterintuitive frames offers new ways to think about the decorative. Watteau's *fêtes galantes*—outdoor pictures of the aristocracy at play and in love—ushered a new genre into the French Academy's hierarchy of painting. These lush landscapes were wholly invented; they never represented a real place (or real people) in time. Watteau's refusal to depict the world with any kind of naturalism in favor of a highly codified form of artifice was seen to be the great innovation of the *fêtes galantes*. In these verdant paintings, members of the aristocracy mingle, flirt, make love, and engage in arabesques of bodily, sensual enjoyment. Watteau's deployment of the decorative was explicit, as he drew from Italian textile and ceramic design and incorporated the lightness of the drawing and the near constant swirl of movement found in such embellishments into the compositions of his lilting and laughing bodies in space.[6] These idyllic paintings, however, do not constitute the only axis of Watteau's emotional register. The famous picture of Gilles standing alone in a foppish satin suit offers the melancholic isolation of the human psyche as a counterpart to the amorous group flirtation of the *fêtes galantes*. It is the very hand-in-glove quality of flirtation and melancholy that makes Watteau so interesting, for what is flirting if not a kind of artifice? And does it not speak of both pleasure and loneliness, is it not both a come-on to the other and a cover-up of the self?

Consider Janaina Tschäpe's work in this framework, as it too teeters between flirtatious voluptuousness and isolation. Her *Untitled* wall work is aglow with color and texture as the artist has layered plasticine into an organic underwater landscape in which biomorphic forms move freely about one another in a kind of ecstatic harmony. That the material is filled with the artist's finger prints, indications of where she has pressed, rolled, and cajoled her material into its new life, recalls the "childlike" pleasures of finger painting and playing with clay. Even the direct application of the work on the wall evokes the benign misbehavior of the child who helps with the interior décor by drawing on the expansive walls of her home. Many of the bulbous and fluid forms of Tschäpe's drawings are found in her photographic work, but their effect in that context is quite different. In *Juju 1* and *Juju 4* we see a female figure enshrouded in diaphanous netting that encompasses her body. Within

the netting large and small ovular forms are simultaneously attached to her from the outside and emanate from within her. The woman is seen as utterly contiguous with her serene surroundings. Both images are of becoming and transformation, and both hold the promise of a magical encounter, in which natural (or supernatural) forces seem to be at play. And yet, in such a massive transformation the autonomy of the figure is lost, her ability to speak or move compromised, her isolation complete.

David Korty's paintings also contain figures in landscapes that appear almost to obliterate them. In *Untitled (Mexico Park)* people mill about in a public square in Mexico, yet the light is so blinding that they appear as shadows, flattened to a two-dimensional version of themselves. Even though the light in Korty's work is a source of great pleasure—the particularity of Los Angeles's flat sulfuric air draped over perfect blue skies is the undertow of many of his paintings—it is also light that envelops his subjects (be they human, landscape, or architecture) in a kind of semipernicious acid glow. His subjects are pushed up against the picture plane, dryly painted in an Easter-basket palette but never approachable. There is no space into which one can move in a Korty painting: even when populated they are often pictures of intense solitude and aloneness.

The painters of *Landscape Confection* are in a sympathetic relation to an account of Watteau that foregrounds the symbiotic relationship between flirtation and loneliness, between visual and bodily pleasure and psychic alienation. Certainly they have made it possible for me to think of him in this way. Grasping that symbiotic connection, they no longer perceive the decorative as a threat to high art. Rather it seems as if many artists deploy the decorative as a tool to both register and ward off loneliness. The decorative is the sphere of embellishment and ornament, mementos and souvenirs, the domain of the interior. It is a carefully orchestrated mode designed to protect its inhabitants from the trials and tribulations of the exterior world. In particular, it appears to be a way to stave off feelings of alienation and loneliness. Think of all of the time and labor women have spent decorating homes and rooms that largely stand empty. Perhaps the ultimate "utopian" promise of the midcentury modern interior is that it offered an empty space for new subjects—no fireplace mantles and end tables filled with knick-knacks and flourishes designed to paper over emptiness. Perhaps the modernist dream of an unadorned interior, and its corollary of pure painting, is bound up with the creation of subjects who no longer feel the pangs of melancholic loneliness. (Think of the heroic nature of Barnett Newman's zips, which turned solitariness into an unadorned virtue, and it's that virtue, perhaps, which keeps the loneliness at bay.)

But it's one thing to hang Newman in the living room, it is another thing entirely to put de Kooning there. De Kooning was alone among the abstract expressionists in his refusal to abandon the figure or references external to the picture plane altogether (often his paintings' evocations of classic landscapes are quite evident). His dogged pursuit of the voluptuous, on a scale always in keeping with domestic space (de Kooning is no muralist), means that his paintings often have a high-minded glee. Look at *Untitled*—where the swirls of blue and pink slam up against patches of fleshy white paint just barely able to stick to the canvas. In front of this picture I can't help but think, "Mrs Dalloway said she would buy the flowers herself." And off Virginia Woolf's extraordinary Clarissa goes into the swirl of London and the interior of her own mind. Clarissa Dalloway is nothing if not lonely and nothing if not determined to paper it over, think her way out of it, move through it, never once letting the solitude deter her from the pursuit of pleasure. It remains telling that almost every description of flowers found in *Mrs. Dalloway* is followed by a registration of a character's loneliness.

The swirl of Woolf's prose and the impasto of de Kooning can be found in Pia Fries's paintings, with their proliferation of paint applications, using tools from a palette knife to a cake decorator. Her work offers us the most contemporary understanding of de Kooning's psychically and physically saturated canvases. Everywhere in Fries's work paint is a three-dimensional material capable of velocity and nuance, able, that is, to hold the metaphorical charge of something other than itself while remaining resolutely what it is, paint. Fries's paintings sinuously flirt their way through the various modes of abstraction on the one hand and landscape on the other. These two poles of painting's history do not appear diametrically opposed to Fries, rather they are roped together by a common concern for the past. In her work the past is constantly in the process of being "recaptured" as she "preserves" abstract painting in the face of technological forms of reproduction. (I think this is why one often finds photographic marks on her canvases.) Her latest recovery project involves the obscure naturalist painter Maria Sibylla Merian (1647–1717). By including torn reproductions of Merian's flower and insect prints in her multipaneled *Les Aquarelles de Leningrad* series, Fries deftly moves her paintings between the perpetual present and imminent decay of nature's bounty and proliferation (the flower shop in *Mrs. Dalloway*) and the melancholic recovery of the past (the appearance of Clarissa's former lover Peter Walsh).

Katie Pratt and Neal Rock also play with the sculptural and exuberant qualities of paint. In Pratt's work paint becomes like spun thread, as if it were a substance extruded from some

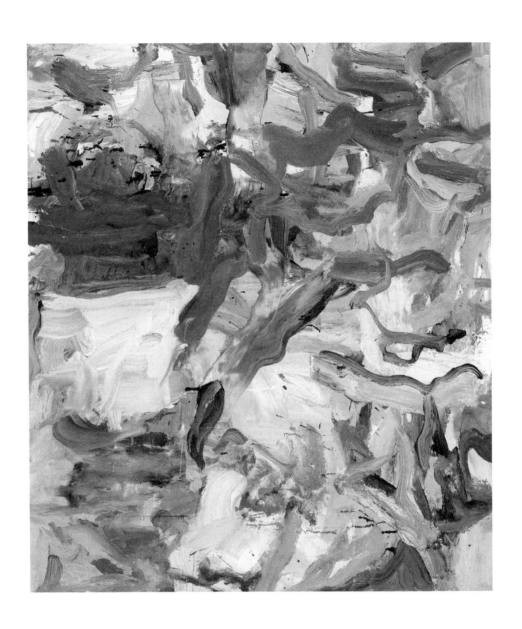

Willem de Kooning
American (b. in Holland), 1904–1997
Untitled IV, 1976
Oil on canvas
80 × 70 in. (203 × 178 cm)
The Menil Collection, Houston

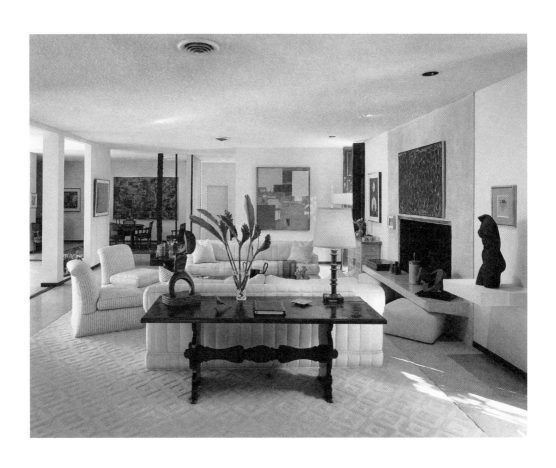

Living Room Interior, Marcia Simon Weisman Residence, c. 1991
© Douglas M. Parker Studio

as yet unknown creature. In these webs and blobs and conglomerations of paint appears a kind of wild fecundity—the big bang as seemingly imaged in the impressive *Spin-Edge* or the slightly toxic bacterial spray of *Finisterre*. In both works beauty and destruction are seen to be part and parcel of the same driving force. Hence, the decorative nature of these works is not held to be a threat as such, rather their excessive quality (often associated with the decorative in the negative) is offered as a kind of biological/astronomical necessity.

Neal Rock is slightly more tongue-in-cheek about the decorative qualities of paint as sculpture and art in general, although the forces of everyday biology and extraterrestrial life still seem to apply. With such titles as *DG/41* and *CL/24*, Rock's fantastical works appear as if they are specimens from another planet. Using the tools of cake decorating, Rock extrudes paint and silicone into baroque concoctions of masses of flowers and swirls that hang together nestled into one another like barnacles clumped on a slippery sea-soaked rock. The works' embrace of kitsch is manifest, particularly with regard to the addition of plastic flowers and the slightly sickening palette. It is the way in which these works play with a kind of humorous abjection, a kind of pleasurable disgust, that make them so different in emotional effect from their modernist predecessors. Rather than treating the decorative (and its handmaiden, kitsch) as a denigrated form of the feminine, artists such as Rock see it to be a source of play, where a historical "fear" is now rendered humorous.

The ability of an emerging generation of artists to view the decorative in this light is, in large measure, a result of the feminist art movement in America during the 1970s. Contemporary art is currently distinguished by the intensity of the handicraft used to produce it. We have seen a variety of painterly techniques in which the paint is quite labored, and evidence of the working methods of the artist is omnipresent. So too a significant amount of work in *Landscape Confection* witnesses the return of sewing and embroidery as "legitimate" artistic practices. Traditionally, needlecraft was considered "women's work" because for centuries women were excluded from European painting academies and needlework was a permitted form of creative expression. Currently, such practices are no longer considered "craft," nor are they gender exclusive. In the face of a culture increasingly dominated by the logic of the spectacle, needlework has emerged in the field of art as a serious endeavor, a way of expressing the tactility of materials, a contiguity between bodies and objects, and a metaphor for binding. So too it signals the incursion of once-marginalized feminist art practices into the dominant discourses of art. Much of the work in *Landscape Confection* can claim as its historical precedent the Pattern and Decoration movement of the

1970s, best articulated by Miriam Schapiro's coining of the term "femmage," a practice she defined as combining "the female tradition of sewing, piecing, hooking, quilting, and appliquéing that parallels and precedes the high art activity of collage."[7]

Feminist artists had a vested interest in recovering the realm of the decorative from modernism's trash heap, and feminist art took up the possibility of the decorative in a dual fashion, similar to the split oeuvre of Watteau. Pattern and Decoration artists celebrated its histories and possibilities, and saw in it a joyous positivity. For others, such as Judy Chicago or Faith Wilding, the decorative was more ambivalent, filled with solitariness, sexuality, and melancholy. Rowena Dring's works embody both of these tendencies. Large canvases composed entirely of appliqué work, they are truly quilts turned into paintings, paintings turned into quilts. Deft in their exploration of the shifts of light and color in the natural environment, Dring's landscapes are also starkly empty and have a pronounced aura of the mechanical. The skill of the sewing and the production of the effects of light are countermanded by the paint-by-number quality of the compositions. Drawing connections between the hobby of Sunday painters and hundreds of years of women's needlework, Dring revels in the pleasures of the decorative while acknowledging the solitary quality of such pursuits and intimating that such activities are a way of staving off the existential condition of loneliness.

Kori Newkirk's beaded curtains exemplify the current embrace of the decorative. His landscapes comprise hair beads strung such that the variation of colors forms desolate, unpopulated, often urban landscapes. The accumulation of parts that make a whole, but that nonetheless retain their bounded separateness, evokes the pointillist painting of Georges Seurat, as well as the more philosophical dimensions of the role of the individual in democratic societies. Newkirk achieves this slightly moody, atmospheric, and dramatic effect through the use of extremely diminutive means. His self-conscious use of a "low," non-art material to make "paintings" and the similarly home-craft or hobby aspect of his work stage the problem of art/craft or high/low. Yet Newkirk does so by creating images of such haunting empty melancholy that they render such binary oppositions uninteresting in and of themselves.

Jim Hodges's work is perhaps the most enigmatic in its melancholic aspect. Delicate silk flowers, lovingly sewn together by hand into diaphanous, porous curtains of color and texture, hang suspended from the ceiling and pool up on the floor. They are works of intense visual delight. Yet *From Our Side* is also a subtle barrier, acting as a scrim that

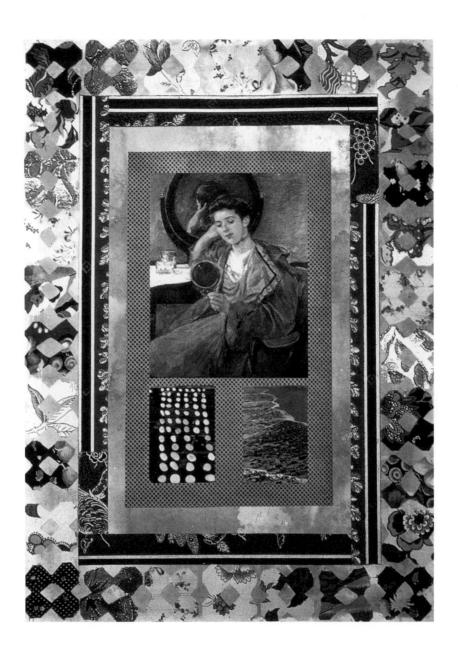

Miriam Schapiro
American, b. 1923 (b. in Canada)
Collaboration Series: Mary Cassatt and Me, 1976
Watercolor and collage on paper
29¾ × 22 in. (75.6 × 55.9 cm)
Collection of the Akron Art Museum, gift of Dorothy Seiberling, 2002.15

fills our visual sense while impeding our physical one. The title alludes not only to the spatial problematic presented by the work but also to the psychic one: From what side is a thing perceived; how does one's placement or point of view affect one's apprehension of a situation? What faith do we have in the notion of an "our" side, with all its implication of community and sharedness? Might not the very spatial problem the curtain poses undermine the title's notion of an "our side" from which we behold anything?

Ranjani Shettar plays with similar problems of placement, point of view, and the shifting nature of visual and physical apprehension in her installation *Vasanta* (Hindi for spring). Like Hodges's flower curtain, *Vasanta* draws you into a visual field of lilting play. Small beads of hand-rolled wax are threaded on tea-colored string, suspended from the ceiling in a sinuous line that resembles a hybrid mobius strip. As one moves around and through the work, the wax "beads" shift color depending on the viewer's position. Changing from lemon yellow, to acid spring green, to a bright clear blue, they magically shimmer and shift, evoking the intensely transitory pleasures of spring blooms, budding trees, and the return of iridescent birds from their winter sojourns. The work, for all of its lightness of touch, clearly required a high degree of handiwork. As if to mimic the intense energy required by spring blooms, the artistic effort of *Vasanta* is funneled into a work of seeming impermanence. Hence *Vasanta*, with all of its promise of new life and new ways of seeing, like the spring blooms it metaphorizes, seems to understand the inevitable demise of all things. Hand-rolled balls of wax—obsessively and delicately painted—suggest, lyrically and subtly, that the embrace of life's small, beautiful pleasures is at once futile and all we can do. That such pleasures are often decorative and bound to our ever-changing notions of landscape is the current offering of many artists.

Notes

1. For more on the problems of the decorative and cubism, see Lisa Florman's "The Flattening of 'Collage,'" *October* 102 (Fall 2002).

2. Adolf Loos, "Ornament and Crime," in *Programs and Manifestoes on 20th Century Architecture*, ed. Ulrich Conrads, trans. Michael Bullock (Cambridge: MIT Press, 1975), p. 20.

3. The most important account of these photographs is T. J. Clark's "In Defense of Abstract Expressionism" in *Farewell to an Idea: Episodes from a History of Modernism* (New Haven: Yale University Press, 1999).

4. Briony Fer, *On Abstract Art* (New Haven: Yale University Press, 1997), p. 42.

5. See Isé's catalogue entry on Gubbiotti in this volume.

6. See Thomas E. Crow, *Painters and Public Life in Eighteenth Century Paris* (New Haven: Yale University Press: 1985), especially chapter 2.

7. Norma Broude, "The Pattern and Decoration Movement," in *The Power of Feminist Art*, ed. Norma Broude and Mary D. Garrard (New York: Harry N. Abrams, Inc., 1994), p. 216.

Artists in the Exhibition

Claudine Isé

Rowena Dring

Born 1970, Wellingborough, Northamptonshire, England.
Lives and works in London.

Influenced as much by the folk-art techniques of quilting, appliqué, and embroidery, amateur travel photography, and kitschy 1970s' photographic wallpaper as she is by op, pop, and Pattern and Decoration painting, Rowena Dring uses stitched fabric to make paintings that collapse distinctions between high art and handicraft, abstraction and representation. In Dring's landscapes, cozily situated beach cottages, rippling waterfalls, fiery-hued foliage at the height of its autumnal glory, and dappled light dancing across the water's surface are all constructed from flat segments of solid color, sewn together with black thread and stretched across a canvas frame. The color-blocked appearance of these compositions recalls the look of comic strips, maps, and old magazine illustrations, as well as the "Everyone can be a Rembrandt" naiveté of early paint-by-number kits and the Sunday painters who purchased them.

Nature's own intricate patternings provide the jumping-off point for Dring's nimble needlework. What at first may seem like a studied genericism in her choice of subject matter belies the difficulties involved in capturing the reflective qualities of water and light. Because she is constructing complex images by suturing differently colored swatches of fabric rather than blending paint, Dring must become something of an illusionist, creating depth, shadow, plays of light, and gradations of form by interspersing colors in intricate patterns. Depending on where one stands, Dring's pictures appear either to break apart into hundreds of fragments or coalesce into recognizable nature scenes. Over time her works have increased in scale, which only enhances these optical effects. *Tree* (2002) and *Untitled* (*Water*) (2002) measure

approximately 6½ x 4 feet and 2½ x 5 feet, respectively. Like picture windows, they invite viewing from multiple positions and proximities, with different experiences to be had each time. What might otherwise be banal nature scenes are made spectacular through the sheer manual dexterity required to make them legible on such a large scale.

When studied closely, Dring's paintings enact subtle dramas about the problematic nature of visual representation. Her subjects must submit to several levels of visual translation: She starts by identifying a locale, either a place captured in a magazine travel photo or snapped by the artist herself during nature walks. The photographic image provides the setting the painting is based on. The translation from photographic image to quilted composition, however, demands an approach that is at once carefully orchestrated and far more intuitive. Breaking the composition apart into hundreds of fragments, Dring assigns each a color and then fits the broken pieces back together again like a jigsaw puzzle. The resulting paintings resemble exploded still lifes, freezing a moment in time in such a way that the actions, and interactions, of surfaces and planes, solid matter and its dispersal, and reflected light become singularly apparent. Each black-bordered segment seems to vibrate fully on its own yet is also part of a macrocosm of simultaneous movements, forces, and events. In the end, Dring brings us full circle by managing to make "wild nature" something truly wild again. Her paintings enact the willful resistance of the "natural order" to the cultural frames and vistas we inevitably want to construct around it.

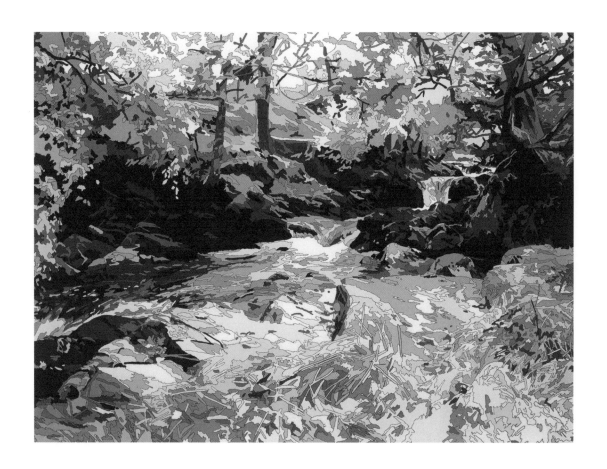

Pia Fries

Born 1955, Beromünster, Switzerland.
Lives and works in Düsseldorf., Germany

The paintings of Pia Fries are unabashedly sensual—some writers have even described them as "exhibitionist"—in nature. Known for her promiscuous use of paint and fearless approach to color, Fries often squeezes paints straight from their tubes and mixes them "live," directly on white, heavily primed wood panels, folding, combing, or fanning a veritable rainbow of wet, viscous colors together as if she were a DJ mixing a psychedelic soundscape. Fries studied with Gerhard Richter in the 1980s, and, like her mentor, she makes dramatic paintings that explore the inherent possibilities of the medium and its rich, rocky history.

Food metaphors are almost unavoidable when it comes to describing the construction and appearance of Fries's works. Paint is squeezed, spread, dripped, crushed, kneaded, and scraped across the wood panel supports. Her armory of application devices includes spatulas, palette knives, brushes, and syringes, along with a host of other homemade contraptions through which she pushes, molds, rolls, and otherwise manipulates paint. For Fries, painting is a plastic art, as much so as sculpture. She employs pure oil paint, sometimes thickened with resin, other times thinned with medium to achieve different textures and consistencies. Each work offers a lexicon of paint applications: thin, watery brushwork; thick, toothpasty rolls; spaghetti strings; fleshy bundles; and feathery, fanlike effects. The colors of ice cream, sorbet, and hard candy—vanilla and chocolate, as well as tangerine, lime, banana yellow, and plummy purple—give Fries's paintings the allure of the edible.

A number of Fries's paintings incorporate screenprints of adhesive crepe ribbon curlicues that from a distance look like brushstrokes. The insertion of this flat, illusionistic photographic material becomes a mechanically reproduced visual quotation of Fries's own painterly devices. Perhaps the artist's reference to photography, painting's historical "rival," along with other forms of mechanical reproduction, is meant as a brazen act of confidence in its juxtaposition of the strokeless sheen of the photographed "brushwork" with the lush, fleshy materiality of Fries's own surfaces. Another group of works, *Les Aquarelles de Leningrad* (2003), incorporates reproductions of plant and insect paintings made by the nature historian Maria Sibylla Merian (1647–1717), which Fries has torn up and used as collage elements. Instead of her typical primed white grounds, Fries here uses glazed plywood panels and leaves the grain exposed, perhaps to provide an indexical counterpart to the filigreed detail of Merian's fastidiously rendered works. Fries then proceeds to paint over and around the reproductions. In "sampling" the work of Merian, Fries links her own concerns and techniques to that of another, very different female "landscape artist" who is separated from her by hundreds of years.

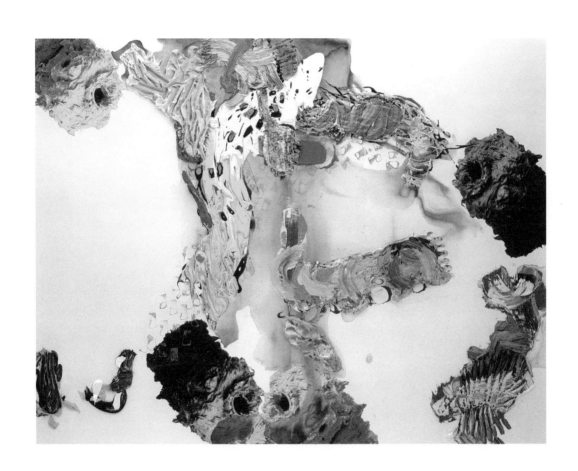

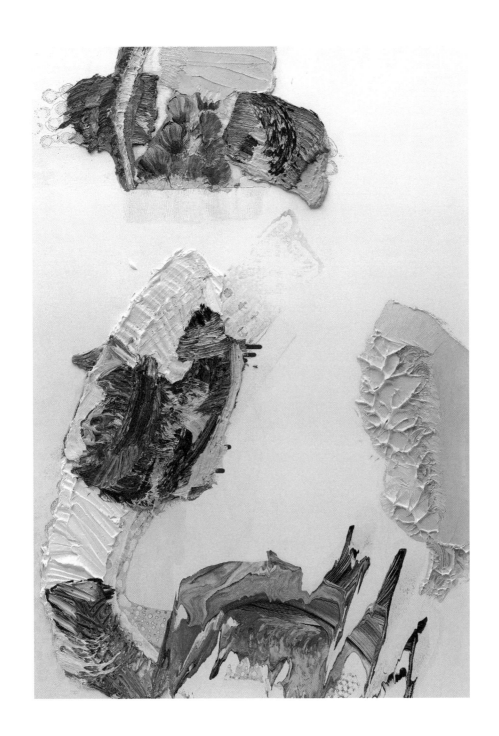

Jason Gubbiotti

Born 1975, Wilkes-Barre, Pennsylvania.
Lives and works in Metz, France.

Jason Gubbiotti does not make a painting so much as he builds one, constructing wooden support systems that step out from the wall or swoop out at viewers, revealing their own structural devices through the naked display of wood, glue, staples, and nails. In Guibbiotti's paintings, the support structures often take front and center stage, activating, and actively performing, the dynamic interplay between materials, surface, and support that paintings have traditionally kept behind the scenes. Further emphasizing the painting-as-building process, Gubbiotti leaves visible traces of the paintings' making: smears of glue; raw, unprimed canvas; and stretcher bars laid bare, exposing the white walls beneath them. Often, large sections of raw canvas are left untouched, while elsewhere the paint is applied sparingly, in light swabs, veils, and smudges. Gubbiotti has also used paint hyperrealistically in order to mimic the grain of the wooden stretcher and further blur the line between surface and substrate. In general his color palette is bright yet reserved, recalling the cheerfully translucent pastel tones of contemporary product design—ice blue, safety orange, and acid green, for example.

Strong enough to hold the viewer's attention on their own, Gubbiotti's compositions are difficult to identify as abstracted views of one thing or another. They may be "landscapes," but not in any literal sense of the word. Smallish biomorphic forms drift and float within vast spatial expanses, sometimes colliding, other times gently sidling up to each other or convening in congenial clusters. Regardless, each painting provides plenty of room to breathe. Perhaps these are landscapes of the mind, charting an emotional or experiential geography that is devoutly resistant to language. Perhaps they are not abstractions at all, but rather attempts to represent, in painterly terms, the step-by-step thought processes that created them.

In order to extend the boundaries of his own painting practice, the artist continually rethinks the fundamental aspects of the medium. He puts each of his paintings under "immense scrutiny," focusing always on the painting-as-object, its past, present, and future. His minimalistic painting gestures—he describes them as the "restless physical mutations that occur from one to the next"—are like the diaristic notations of the artist's wandering mind as he attempts to see through solid walls and peer around conceptual corners. Writer Ana Honigman characterized Gubbiotti's marks as "moving through the pictorial frame as if on a mission," in an essay written for Gubbiotti's 2001 exhibition at Fusebox in Washington, D.C. This fleeting quality makes each gesture look as if it is hovering somewhere between past and future tenses.

When you swing around the sides of these fetching surfaces, however, the illusion of pure frontality is destroyed, and the painting begins to break apart into its constitutive elements. A frontal perspective is possible only as long as the viewer holds her own position; move slightly to the side and the view is immediately interrupted by the presence of roughly articulated wood constructions that look like a home building project gone haywire. The jig is up, for no longer can we pretend that a painting is some kind of mental projection effected solely through the skillful manipulation of paint. Gubbiotti shows us that paintings have their own architectural identity, and thus have a lot more in common with the walls on which they're hung than anyone may have thought.

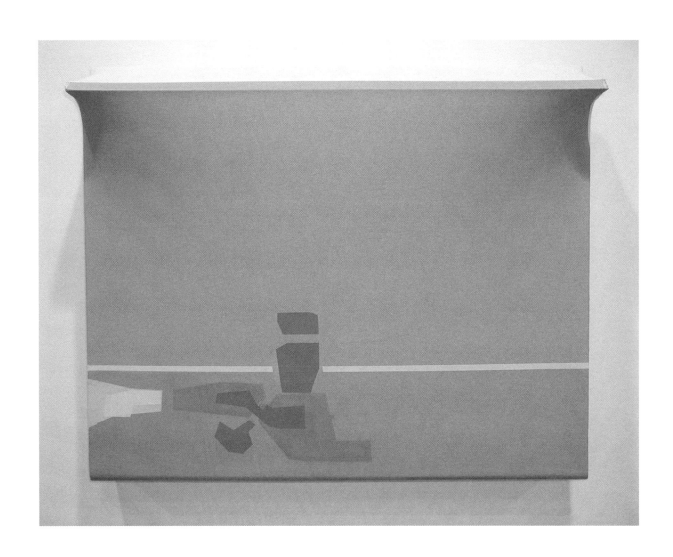

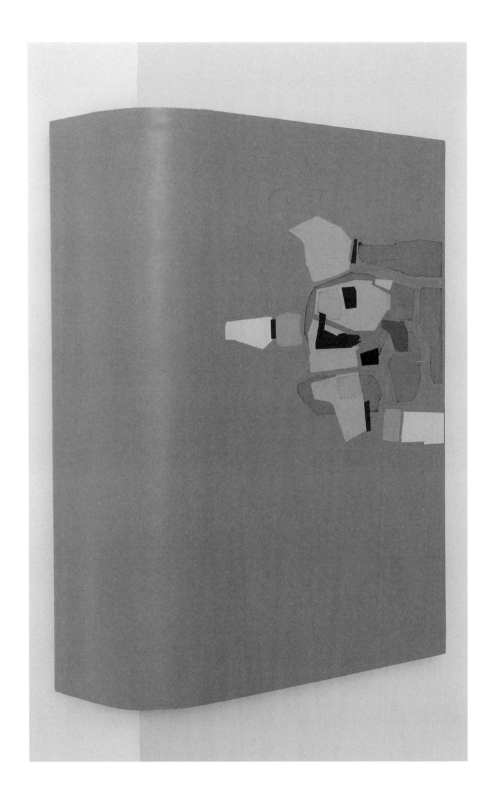

Jim Hodges

Born 1957, Spokane, Washington.
Lives and works in New York.

The result of hundreds of minute, loving gestures, Jim Hodges's art manages to be at once spectacular and intimate. The power of touch resonates throughout his compassionate and deeply romantic oeuvre. Whether he is sewing thousands of silk flowers together to form scrims of explosive color, weaving dozens of slim silver necklaces into sparkling webs, or slicing and folding the edges of large-scale landscape photographs to playfully embellish them, Hodges's attention is directed towards the poetic resonance of fleeting moments and ordinary things. *Endlessly*, a 2002 installation, is a deceptively simple photographic documentation of the world seen through Hodges's eyes. The photographs sometimes are clustered on a wall with a camouflage background, as if to emphasize the underlying rhythms and patterns that, once discovered, imbue our lives with meaning. Hodges's humble incursions into the mundane crack open a space of wonder; we leave the presence of his works wanting only to return again and again.

Many of his drawings and installations involve the artist in painstaking, time-consuming labor. Similar objects—the silk flowers, small squares of colored paper pulp, shards of mirror, paper napkin doodles—are accumulated by the artist over time and then combined in dense skeins that recall Pattern and Decoration painting as well as the "low" domestic hobbies of flower pressing and arranging, papermaking, and embroidery. Hodges thinks of his works as fragments from an ongoing diary, wherein moments of his life are recorded and reenacted through the collection and reassemblage of souvenirs and mementos. Significantly, the trinkets and tacky treasures that provide Hodges with his raw materials could just as easily have been tossed away. By investing them with time and attention he transforms insignificant things into objects of monumental importance.

The poetic, wistful titles of Hodges's works reveal the longing that underlies them. A silvery metal cobweb, titled *Angels Voices* (1993) and tucked surreptitiously into a corner near the ceiling, can be viewed literally as a web (the "web of life"), but also metaphorically as a portal into a space beyond, as the ghostly remainder of a creature's "happy home," or, one may also surmise, as a murder scene. Part of the piece's sense of fragility derives from the fact that it is so easy to overlook, perched as it is above our normal line of sight. Yet Hodges has made this cobweb into something that refuses to be brushed away, and in this the piece reminds us of the gentle persistence of memory. *From Our Side* (1995), a 10 foot by 10 foot silk flower curtain, presents a screenlike divide between two spaces that viewers can look at but not pass through. Its shower of flowers evokes a million romantic afternoons spent picnicking or walking through the park, but it also brings to mind the funerary flowers bestowed on a deceased beloved. The flowers dazzle in their riotous color and profusion of detail (who knew that so many different types of fake flower existed?), but these delicate daisy chains are more impenetrable than they first appear. Their dense weave forces viewers to look *at* them, not through them. They point to a place we have no access to—or maybe one that doesn't even exist. Perhaps all that we'd find behind the curtain is an empty plot of gallery space: the museum as mausoleum.

Hodges's pieces ultimately register the mark that other human beings have made on his own life. His works evoke the memory of human touch and the pain of its inevitable loss. Hodges's works attempt to hang on to those lingering moments, in all their ephemeral loveliness.

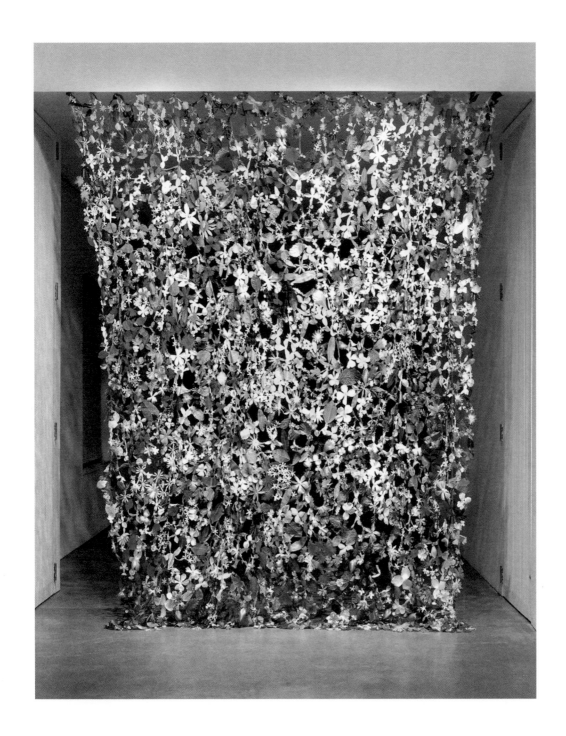

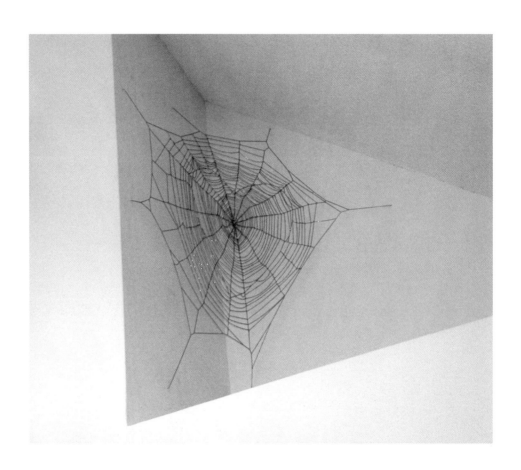

David Korty

Born 1971, San Francisco, California.
Lives and works in Los Angeles.

Visitors to Southern California often marvel at the quality of the light there, a bright, diffuse kind of light that is difficult to describe but is immediately apparent upon arrival. David Korty, a young Los Angeles–based painter, attempts to represent that light during different times of day. His paintings capture the smog-hued sensibility of urban L.A. Awash in smoky pinks, hazy blues, toxic greens and yellows, they are picturesque without being sentimental. His subject matter is familiar to those who live in or have visited the city for a time. Viewed through an impressionistic symphony of splashes, drips, and drops, we are shown a mishmash of unpretentious canyon homes, stacked in rows on a hillside, or freeways seen through a dirty car windshield, the refracted light enhancing the psychedelic effects of sunset.

Beyond the expansive vista, Korty has an eye for the more minute pleasures that can be found by those who care to look: a smallish bed of bright flowers nestling against a chain-link fence, for example, or a police station parking lot that is slowly being overrun by trees, junk, and unchecked shrubbery. Even a sea of garbage cascading down a hillside has an ebullient feel, because Korty's touch is light and his gaze resolutely nonjudgmental. He is an impressionistic observer, and maybe even a lover, of Los Angeles, not a raconteur chronicling the mounting woes of the "apocalyptic city of Angels."

Many of Korty's early works were nightscapes tinged with an acid-rainbow, all-night-desert-rave feel. Depicting Los Angeles at dusk and at night, they flirted heavily with pure abstraction—some seemed to consist of little more than expertly aimed spatters of paint—and yet arguably these works conveyed the gorgeous atmospherics of the city after hours more successfully than those by any other painter of recent memory. More recently, his paintings have grown much paler in hue and his attention has turned to daytime scenes taking place at beaches or parks. These newer paintings have the tonal qualities of overexposed photographs. Yet unlike photographs, which fix an image in time, the places depicted in Korty's paintings seem to be disappearing before your very eyes. They are almost unreadable when reproduced in books and magazines; even when seen in person they require close scrutiny to determine what they are. As before, Korty is concerned with the dissolution of vision through paint; he wants to make us question what we are seeing even while we are struggling to make sense of it. In their visual reticence, his paintings remind us that even though these places may seem familiar, even to the point of banality, they will in fact never look quite that way again. As the marvelous white light of Southern California shines its brightness on the passage of all things, Korty stands waiting, ready to paint them into posterity.

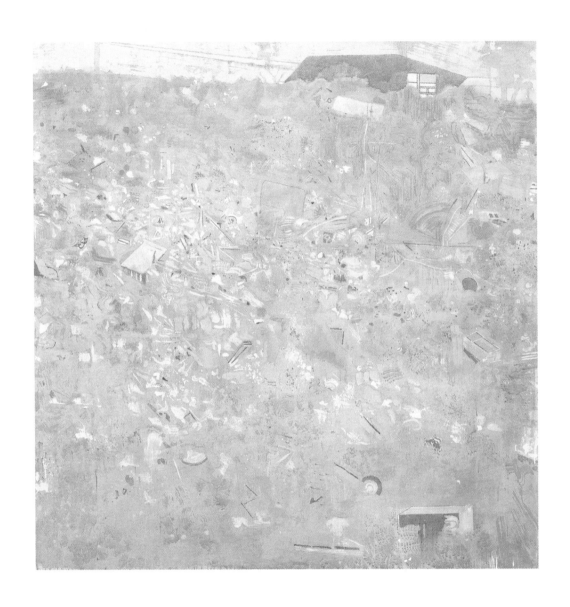

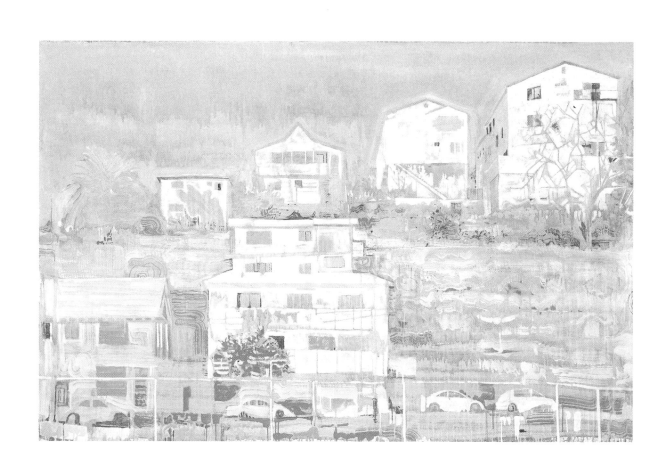

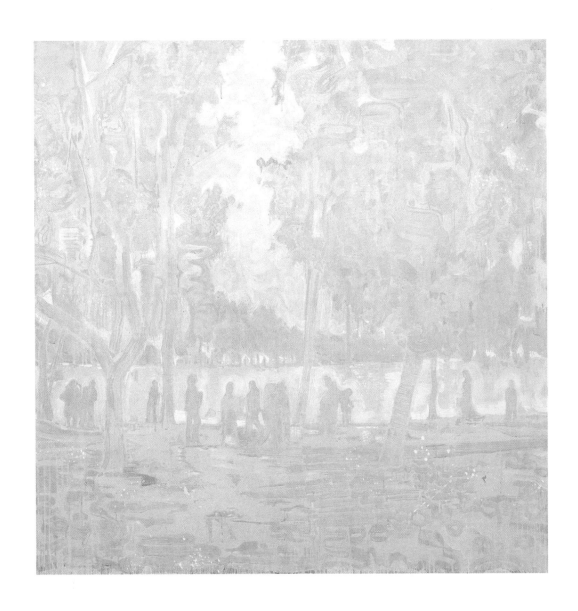

Kori Newkirk

Born 1972, the Bronx, New York.
Lives and works in Los Angeles.

Kori Newkirk employs a variety of unusual and culturally resonant materials (including synthetic hair, wax pomade, and plastic beads) to create mixed-media installations that investigate the connections among history, place, and racial identity. Bringing to mind cornrow hairstyles, as well as the now-kitsch beaded room dividers that were popular in the 1970s, Newkirk's "curtain paintings" are made by stringing colorful, plastic "pony beads" through thinly woven strands of artificial hair (micro braids) in carefully executed patterns. Hung on walls like traditional paintings, they depict fragmentary views of natural phenomena, outdoor vistas, and anonymous urban and rural landscapes. LK-3 (2004) presents a frosty expanse with a horizon outlined by a patchy stretch of trees. Set slightly apart, a tall tree stands near two smaller ones, with a larger fourth tree positioned farther away, like an estranged family member. A vast stretch of snow (a recurring motif in Newkirk's work) occupies the rest of the composition, increasing the sense of isolation.

Stutter (2002) depicts the side of what appears to be a modernist domicile; whether it is a house or an apartment building remains unclear. Newkirk uses orange, tan, cream, and brown beads to construct this low-roofed dwelling out of a series of solid, variously sized rectangles that form a sort of imperfect grid. Like most of Newkirk's compositions, Stutter can be difficult to "read" at first. The beads seem to alternately coalesce or explode, like digital pixels, depending on where the viewer stands before it. Newkirk's paintings present a relationship to the concept of "home" that similarly vacillates between presence and absence, comfortable recognition and estrangement. In his works houses are depicted at somewhat of a distance, always partially obscured from view by trees or shrubbery, so that the shelter and security they would ordinarily offer always seem just out of reach.

"I always knew that Black was beautiful in the '60s and powerful in the '70s, but growing up in central New York state in the '80s and '90s, I didn't know what Black was supposed to be for me," Newkirk has commented (V Magazine, March/April 2003). Although his landscapes are devoid of human figures, their compositions are framed in a manner that implies the point of view of a specific body in time and space. The body that inhabits this space could in theory belong to anyone, but the culturally coded materials that Newkirk employs in his works suggest that the particular memories and experiences embodied in these places could not. In his works the figure of the black American "appears" only as an absence, often manifested through a metonymic substitution of hair or its accoutrements for the missing body. In addition to the pony bead curtains, Newkirk has made large-scale wall murals out of tinted pomade hair straightener, using the waxy material to paint and, at points, even sculpt his compositions against white walls. In one such piece, the silhouette of a police surveillance helicopter—a commonplace specter in urban communities—appears like a menacing shadow. Another recent wall work, made for the Museum of Contemporary Art in Cleveland, consisted of the artist's fingerprints, enlarged to hundreds of times their original size, painted on the wall with a mixture of pomade and pigment. Mining the rich history of African Americans, Newkirk's conceptually based works investigate what being black meant to previous generations, and what it means to people of all races today.

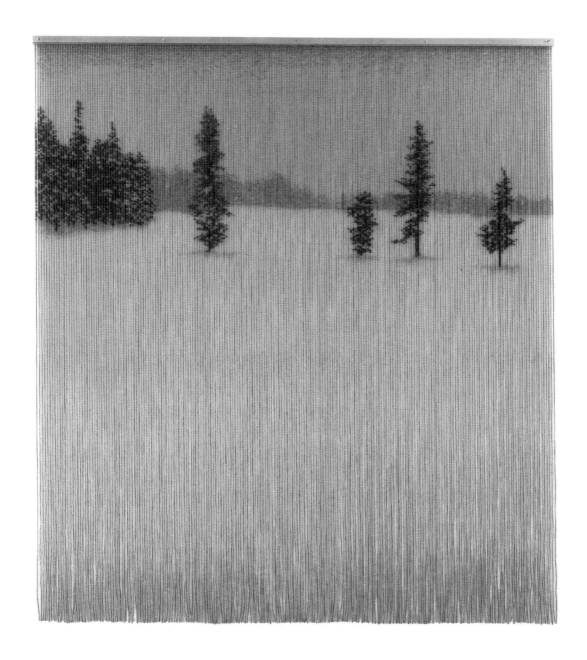

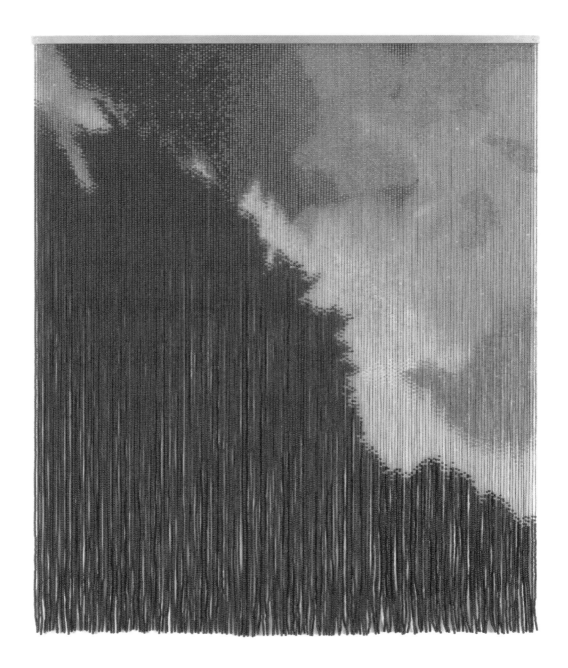

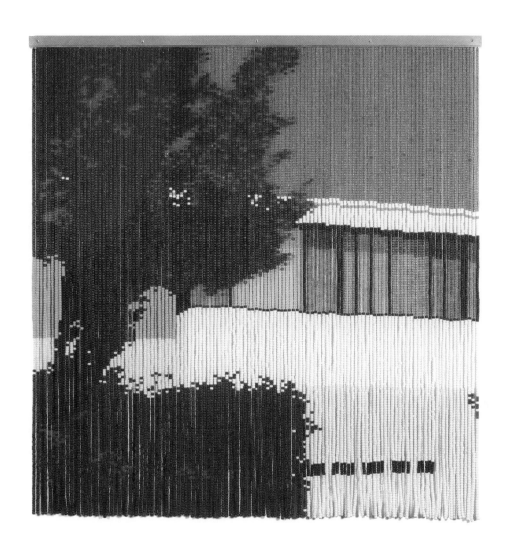

Katie Pratt

Born 1969, Epsom, Surrey, England.
Lives and works in London.

Juxtaposing intricate web and whorl patterning, repetitive mark making, and absentminded scribbles with thick impastos of paint, Katie Pratt's canvases offer up strange, verdant topographies of the unknown. Alternately they also resemble heavily magnified views of the sorts of tiny life forms that inhabit tide pools. To look at one of Pratt's paintings is to feel as if you are constantly shifting between micro- and macroscopic lenses. This is achieved formally through her varied use of paint. At times she applies it thinly, in agitated, excremental "splashes," with the edges of each color field sharply delineated from the other by heavily outlined, maplike boundaries (see *Finisterre*, 2002). At other times the paint is doled out generously in gobs, daubs, and slathers, or rolled into crinkly fringes that hang limply off the canvas's surface like plankton or algae. These gangly, dripping offshoots extend the field of the painting from the space of the canvas proper, also placing emphasis on painting as sculptural object.

Typically, Pratt's compositions begin with a single splash of paint. The artist has said that she treats this initial gesture as a "found object" that presents a series of problems that the rest of the painting must solve. As the work progresses, Pratt studies the compositions intently, slowly identifying rhythms, themes, and patterns and then highlighting these charged territories with diagrammatic lines or the application of thickly painted borders. What was once imperceptible is thus magnified through the artist's obsessive scrutiny and inscription. The process of "working through" the painting leaves traces that become a sort of roadmap that the viewer can follow in Pratt's wake. The titles of her paintings—*Bushton, Marienstadt, Scoop-Lake-City, Dervishire, Purling, Planctonbury Ring, The Screedings*—sound like the names of places, further encouraging viewers to read the works as topographic metaphors for travel and exploration.

The canvas also becomes a site of excavation and constant experimentation for Pratt, who in 2001 was awarded Britain's prestigious Jerwood Painting Prize (the most valuable single prize awarded in the U.K., granted annually to an artist who demonstrates excellence and originality in painting). She strives to create a sense of meaning and order out of the chaotic system that that first, unpredictable splatter represents; it's the "big bang" moment from which all of her paintings eventually emerge. "For me," Pratt has noted, "this beginning is the ironic antithesis of my approach to painting, which is anything but expressive, and rejects any pleasure or beauty that may be perceived to emerge from the paint itself." Instead, the resulting works chart the various ways that paint behaves when confronted by certain conditions. When poured or splashed, the paint ripples, pools, splatters, and folds. When faced with the pull of gravity, the still-wet blobs may buckle or burst, or slowly drip downwards, threatening to exceed the boundaries of the canvas. By pitting rigorous and systematic scrutiny of her paintings' surfaces against the unpredictable changes that occur within the medium of paint itself, Pratt becomes the maker of worlds she cannot master, but can only study, map, and marvel at.

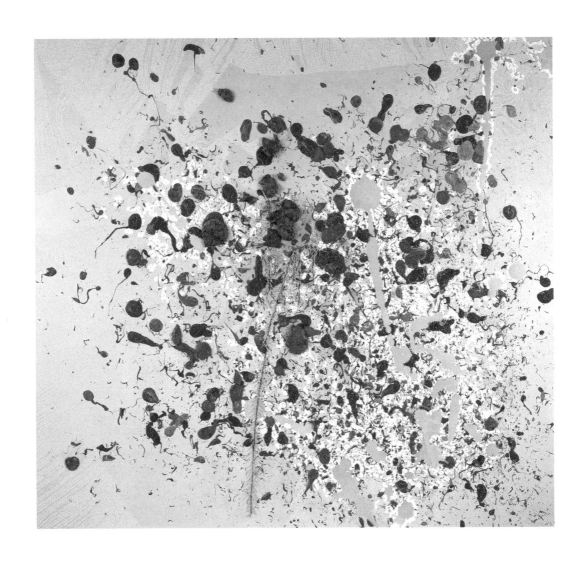

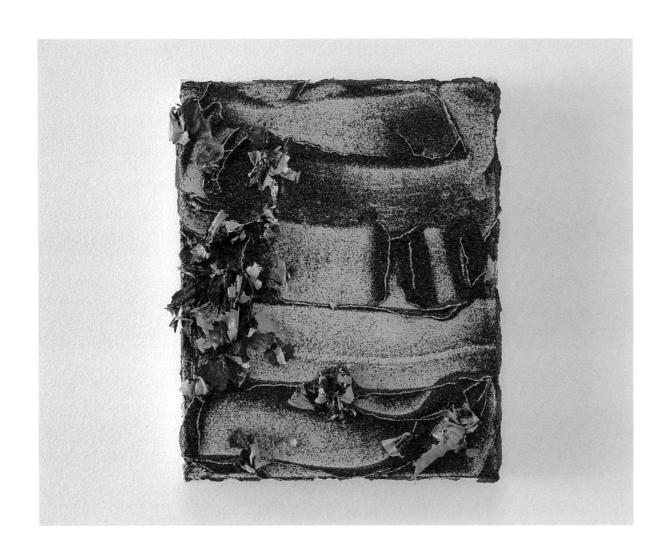

Michael Raedecker

Born 1963, Amsterdam.
Lives and works in London.

Michael Raedecker's needlepoint landscapes are marked by a distinctive combination of heady surrealism and hokey handicraft. Before becoming an artist Raedecker studied fashion design, and his nimble way with a needle and thread has served his paintings very well. Drawn from the collective memory of popular culture and movies, especially those set in remote rural locations (*The Blair Witch Project*, *Misery*, and *Friday the 13th* come to mind), Raedecker's subject matter tends toward the mundane: sparsely appointed interiors, barren deserts, and outdoor landscapes sprinkled with snow, a few small, boxy domiciles visible from a distance. Human figures (expect for an occasional portrait) are almost always absent from Raedecker's paintings.

There is a sense of loneliness and isolation in the places he depicts, which look both familiar and deeply strange. Raedecker's earlier paintings returned again and again to a certain type of shabby dwelling—usually single-story A-frames—as if this place were a key trope in a series of recurring dreams. It is difficult to imagine the type of family that lives within these anonymous exteriors. When Raedecker does bring us inside, we are confronted with an abject emptiness that is by turns sad and chilling to behold.

To view a Raedecker painting is to be confronted with its undeniable materiality. The paintings' dramatic textural qualities emerge from the artist's partiality to thread and wool as expressive substances. Sometimes he embroiders his images onto the canvas, other times he glues thread and yarn onto the surface in meandering, clumpy strands that look like micro-thin lines of paint. He pushes painting's dimensional possibilities even further by laying fibers on in small tufts that stand for treetops and dense foliage or applying thin strips of wood veneer as wood paneling. Although his paintings often feel somber in tone, moments of wry humor crop up in the ways that Raedecker toys with the viewer's sense of perspective. When generously applied, the yarn or thread may cast tiny slivers of shadow alongside the painted ones.

Raedecker's skillful mixture of paint and fiber often produces surfaces that reveal stray bits of fibrous matter encrusted beneath. Sometimes loose threads pull away from their surface grooves like strands of a frowsy hairdo, or are scattered across the surface in tiny balls like a pilling sweater, giving us the sense that his paintings have literally come undone. The writer Bart Verschaffel has observed, "Raedecker's paintings are 'unsettling': we do not readily comprehend what is actually happening in them nor do they offer us an ideal viewing distance from which we might feel that the image coalesces into an accessible whole." (*Parkett* 65, 2002, p. 98). Instead, the paintings revel in their impurities: they are "messy," even somewhat soiled, covered as they are with microscopic fibrous matter that clings to their surfaces like dust. At the same time, nothing in Raedecker's canvases seems accidental. Each strand of thread, each loose speck of matter, looks deliberately placed. Indeed, there is a carefully cultivated quality to these paintings that evokes the diminutive precision of dioramas, terrariums, and other miniaturized landscapes. In turn, there is a quixotic aspect to Raedecker's exquisite attempts to shape and control the microscopic strands of fiber—his compositions, arranged just so, look like they could be blown asunder with a single sigh. Like recollected dream images, they are wispy and fragile, rooted out of a collective unconscious and tethered to reality with a few tenuous lines of thread.

50

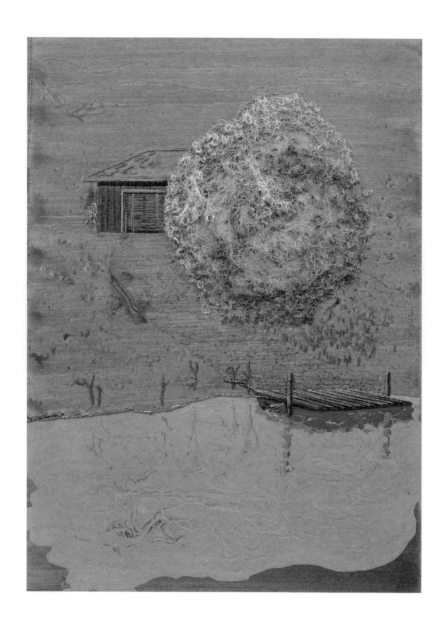

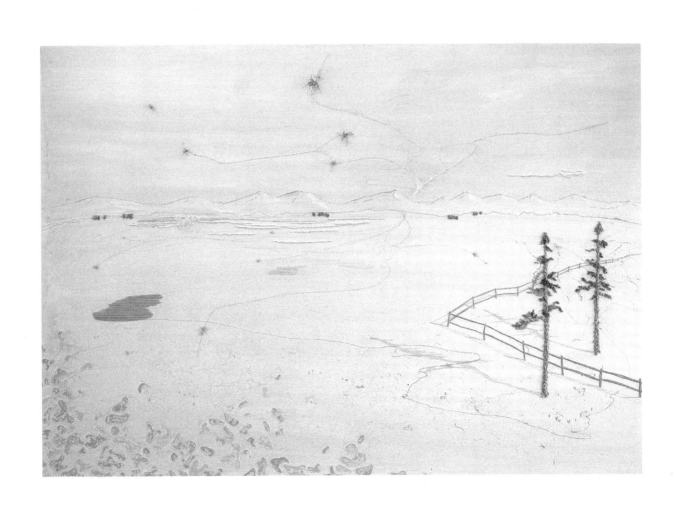

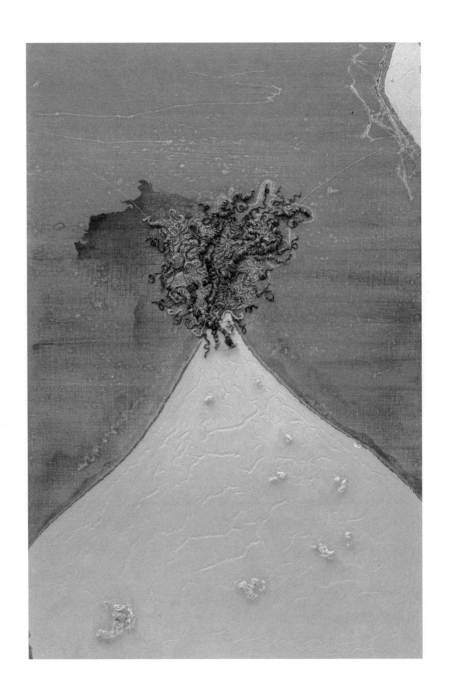

Neal Rock

Born 1976, Port Talbot, New South Wales, Australia.
Lives and works in London.

Occupying a domain of ontological uncertainty between painting and sculpture, Neal Rock's candy-colored agglomerations of pigmented silicone cling to their edifices in gooey nests, clumps, and splatters. Although they appear to grow directly out of the walls, they in fact are formed around three-dimensional armatures. Rock squeezes the silicone through a pastry bag, layering it on so thickly that it overwhelms and hides its underlying support structure. This gives his works an "overgrown" quality that evokes the formless patterns of moss, slime mold, or coral. At once ridiculous and utterly fetching, Rock's confections can be intensely alluring (the desire to reach out and touch, and even to lick, his works is dangerously tempting), yet at the same time they may also evoke a faint sense of revulsion, not unlike the feeling one gets after eating too much candy or cake batter. The squeezed silicone has a thick, tentacular quality and glistening sheen that evokes octopi or jellyfish as easily as it does strands of taffy or ribbon candy. Tucked within these fleshy folds are tiny paper flowers and other decorative gewgaws that send Rock's already baroque constructs careening exuberantly over the top.

Rock's painterly concerns manifest themselves in his approach to color, composition, and materiality; where his works depart from those of painting proper is in their engagement with issues of three-dimensional form. Each of Rock's works is the result of an additive process that is a bit like that of cake decorating or pulling sugar. He builds them up and outwards in layers, "arranging" the forms, textures, and colors as he goes, so that the results look like bouquets. The stickiness of this process leaves little room for error, however, and thus a large degree of intuitive risk taking is involved in "building" the forms. The chocolate curls, ruffle garlands, and gumpaste flower buds that often adorn the tops of wedding cakes and specialty pastries provide the fundamental building blocks of Rock's painted constructions, but in his works these "painterly" gestures are entirely divorced from what little utility they once possessed. Not only are Rock's rubbery swirls inedible, they are without purpose: a series of decorative embellishments piled on top of one another, existing solely for their own sake.

This effectively turns high modernism's valorization of "pure paint" on its head and poses certain philosophical conundrums that Rock's works gleefully unravel. Although his paintings look like food or flowers, they cannot be eaten, worn, or touched. They inhabit the wall like paintings, but have the dimensionality of sculptures. They evoke flower garlands or bouquets, but conspicuously lack the fresh smell of authentic blossoms. Ultimately, Rock's goopy mountains of paint are uncompromising in their refusal to "be" what we expect to them to be. They are fake when we want them to be real, waxy and distant when we want them to yield to our touch, and presumably tasteless although we yearn to sink our teeth through their juicy surfaces. Beautiful and useless, they flaunt their status as art objects, insisting that that is enough.

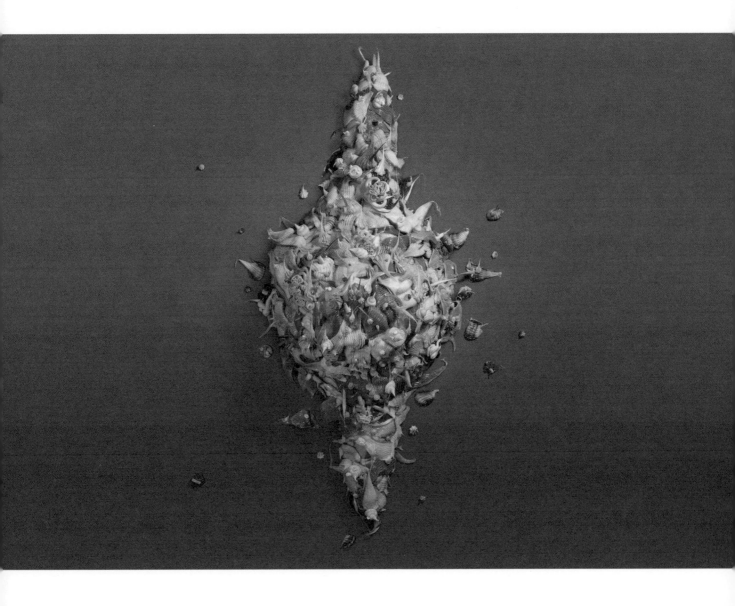

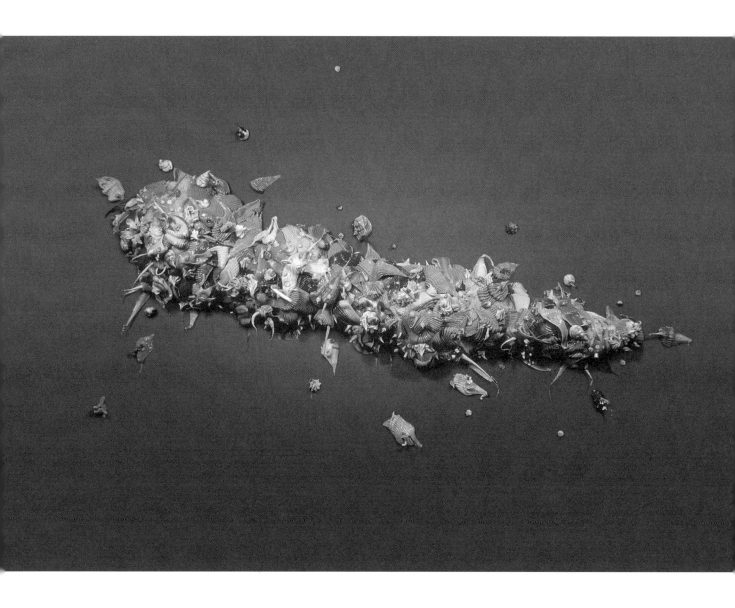

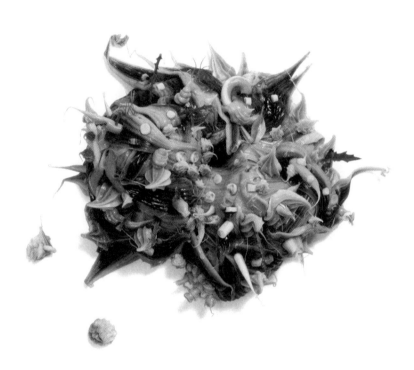

Lisa Sanditz

Born 1973, St. Louis, Missouri.
Lives and works in New York.

Lisa Sanditz's paintings examine the relationship of people to the natural environment, often in the context of outdoor recreational activities such as tailgate parties, sports events, camping, and backyard cookouts. The catch, however, is that a typical Sanditz landscape is depopulated, imbuing her works with a distinct sense of melancholia despite their high-spirited color schemes. She has described her works as "a response to places I have lived and experiences I have had, which have qualities I find to be either lacking or overlooked. Currently, I am focusing on a globally reaching American landscape, created out of a collision of artificial and natural forms." Focusing on certain types of quintessentially American pseudolandscapes—artificially structured environments such as shopping malls, freeways, golf courses, and other constructed landscapes that impose a distracted experience of space and time—Sanditz aims to reconnect us physically with the world where, as she explains, "natural experiences seem to be only a memory. [My paintings] are fantasized depictions of specific experiences or a summary of a collection of experiences."

Sanditz's use of bright, psychedelic colors, casual brushwork, flattened perspectives, and patchwork-quilt compositions gives her paintings a homespun, folksy feel that evokes the work of self-taught or "outsider" artists. (Sanditz, however, studied at the Pratt Institute, Brooklyn, New York, and at Macalester College, in St. Paul, Minnesota.) Using a color palette derived from "cheap house paints," especially mis-tints, the incorrectly mixed paint colors that wind up in the hardware store's bargain bin, she creates dense, tapestry-like landscapes that suture aspects of urban and suburban space seamlessly together. In *49th and Clarke Street Park, Oakland, California* (2003), a McDonald's sign sprouts from a patch of red ground, competing for space with the lush green trees surrounding it. *Dolly Parton's Peaks, Knoxville, TN* (2003), which is presumably a view of the Dollywood theme park, shows a glittering townscape at night. We see a mélange of colorful, jewelry-box-sized abodes nestled snugly behind two hilly mounds of earth as a pair of flowery mountain peaks rise like rosy nipples against the pitch-black sky. Although Sanditz gently tweaks the idea of a corporate-branded theme park promising homespun, "family values" entertainment, it's clear she's as charmed by the possibilities as anyone else.

Sanditz is interested in capturing the peculiarities of the American landscape as it exists today. Yet her work does not eschew nostalgia entirely, for the artist freely admits that the kind of outdoor pastimes she depicts may also be disappearing. Social atomization—Sanditz describes it as living in "our private bubbles"—threatens to distance us even further from each other, and by extension from the natural environment. Why sit around a flickering campfire being eaten alive by bugs, the logic goes, when you can "camp" indoors, nestled in a blanket on your sofa, staring at the comforting light of the television screen? This is likely why Sanditz's pictures are tinged with sadness, despite their raucous jumble of color, line, and form. They depict a world of fun-filled group activities minus the groups, where everything is in place except for the people.

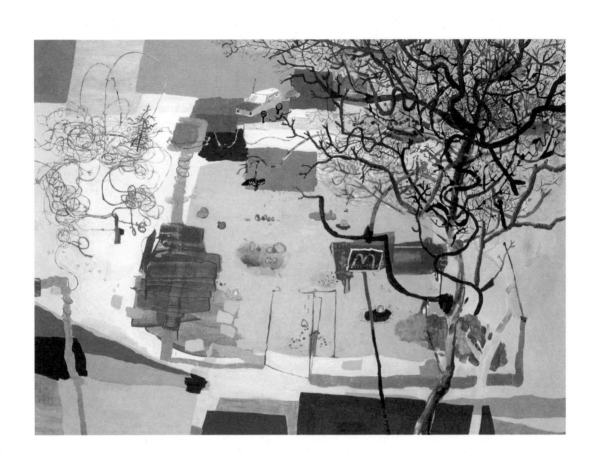

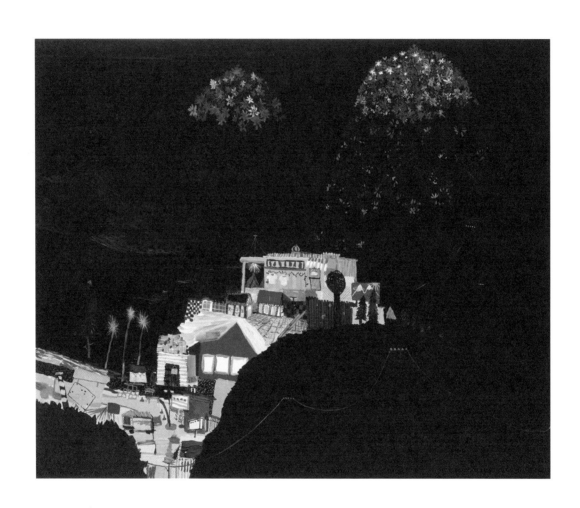

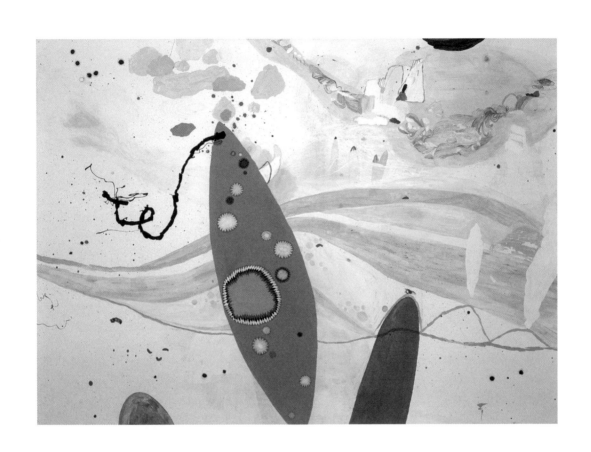

Ranjani Shettar

Born 1977, Bangalore, Karnataka, India.
Lives and works in Bangalore.

Hundreds of handmade beeswax "buds" connected by a complex circuitry of colored thread compose Ranjani Shettar's *Vasanta* (2004), which in Hindi means springtime. The strings are dyed with natural pigments and suspended from different points of the ceiling and corners of the wall to form delicate, hivelike environments. The nodules of rolled beeswax serve as the joints—points of connection and subtle articulation—between the strands of thread that make up Shettar's sculpture. In this way, the form of her work evokes nature's networks: beehives, ant colonies, cobwebs, rhizomes, root systems, and other structures that expand horizontally and have no true center. The space of the installation appears to weave itself around the viewer like a spiral, sometimes enveloping her, other times serving as a barrier beyond which she cannot pass, all of which gives a sense of being simultaneously inside and outside of the piece. The organic materials Shettar employs, such as beeswax, pigment, ink, and resin, link her works to the earth's materiality. But in its seeming defiance of gravity and its intricately interrelated nodes, *Vasanta* resonates equally with the concept of an infinitely expanding universe.

Vasanta may bring to mind Eva Hesse's hanging pieces, although Shettar's lightweight webbing evokes the ephemeral and ethereal whereas Hesse's use of rope and PVC tubing emphasized the visceral and abject. Like Hesse, Shettar is interested in the collision of opposites, and particularly in the confluence of the organic and the industrial, the ancient and the modern. Arising from a specifically Indian context, her handmade "networks" also allude to the speed with which contemporary technology is infiltrating India's economy and everyday urban life—and to the artist's concurrent desire to remain connected to nature's own unique cycles. In the mid 1990s North American software developers began to outsource to India, and India's software exports have risen dramatically since that time. India's abundance of skilled human capital has made it an important new hub for global information technology, and many economists predict that the country will soon blossom into a fully developed nation. Such economic and social growth must surely contribute to the sense of hopeful transition that Shettar's "springtime" celebrates.

Recently, Shettar fabricated a series of "homes" out of various materials such as translucent polythene sheets, resin, and synthetic cotton. The resulting forms evoke pods, beehives, cocoons, tunnels, tents, and other shelters made and used by insects or animals. Shettar's creations emphasize the spiritual and emotional aspects of dwelling. In this way they serve to broaden our understanding of "home" within an increasingly globalized context in which notions of national borders appear to be expanding while, in the wake of the increasing sophistication of the Internet and satellite communications technology, our internal sense of geographic distance is collapsing. Ultimately, Shettar's installations offer moments to reflect on what it means to be connected to something, whether that connection occurs between human beings and the natural landscape, individual consciousness and cosmic awareness, or local traditions and global imperatives.

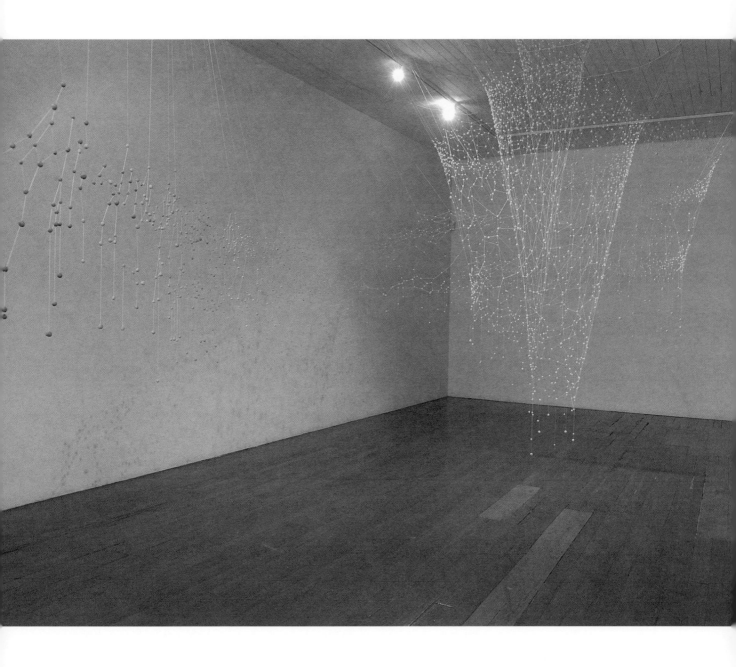

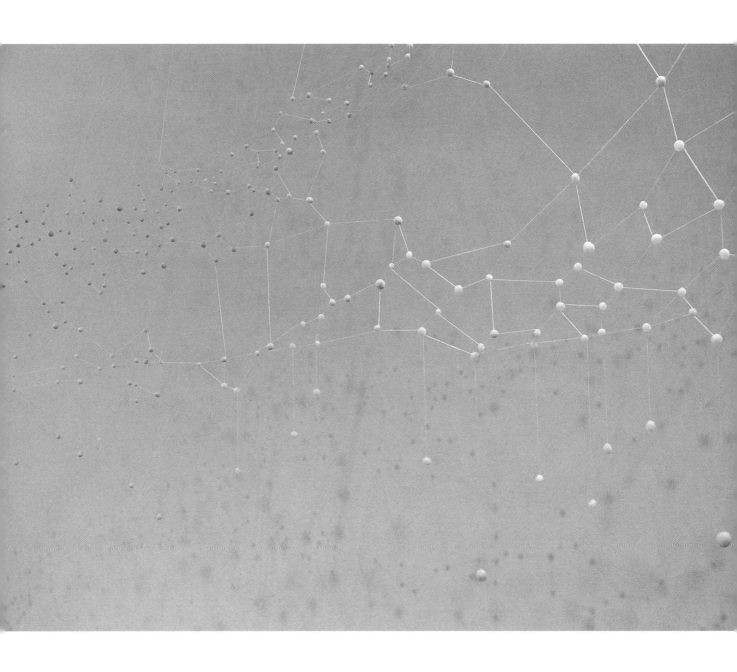

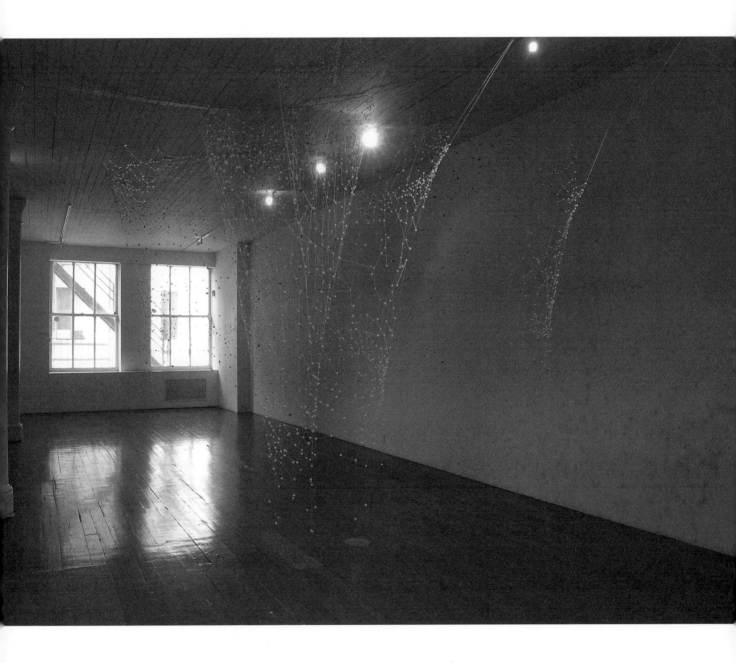

Amy Sillman

Lives and works in New York.

Like ships in bottles or glass snowglobes, Amy Sillman's paintings portray worlds within worlds, spaces that fold into other spaces, and dreamlike narratives where the line between real and imagined is impossible to discern. In one painting, a tiny ship is beached in the lower left corner of the composition. The vista is itself curved almost into a circle, with the edges of the sand curling upwards, the ocean rising into a gigantic wave that licks up into the entire right side of the canvas, blending seamlessly into the sky. Suspended within the wave's embrace is a translucent orb that contains its own tiny, swirling nature scene that duplicates the main composition. We see two bodies of land separated by what could be air, or perhaps just more water. A flag is wedged into the ground, and what looks like a wispy human figure stands beneath it, dwarfed by its size. The painting is titled *Columbus Day* (2001), and its implied narrative circles around and in turn is encircled by a seafaring hero's quest to find "the new world," and, in the process, prove once and for all that the earth is round.

Another painting, titled *Valentine's Day* (2001), operates according to a similar Chinese-box structure. Here, an underwater world contains the faint outlines of what may be a ship and, even more faintly rendered, the outlines of another ship that could perhaps also be an Atlantis-like crystalline city. Spurting upwards from the oceanic depths like from the parting of the red sea is a fleshy body of land that contains a smattering of green trees. Pressing just beneath the surface of this pinkish mass is another of Sillman's shimmering bubbles, within which a tiny human figure appears to be tangled up in languorous ribbons of paint.

What we see in Sillman's paintings depends on how open we are to the spare suggestiveness of her lines. Her signature loose, webby brushwork—densely woven together like rubber netting—at once suggests and obscures a range of narrative possibilities. *The Egyptians* (2003), employs a toasty, sun-streaked palette of oranges and yellows shot through with flashes of ocean blue and seaweed green. The horizontal slashes in the painting's upper half are densely striated, suggesting dappled sunlight reflecting off water. In the painting's lower section, Sillman's lines become increasingly dense and agitated, yet no less purposeful. We can see the beaked profiles of what appear to be a flock of birds. Rising upwards in a triangular movement are a number of angled lines that suggest the sails of a ship. Yet this is only one possible reading; Sillman's compositions are elastic in nature, alternately expanding and contracting to reveal a multitude of possible worlds, a plethora of potential views and narrative interpretations.

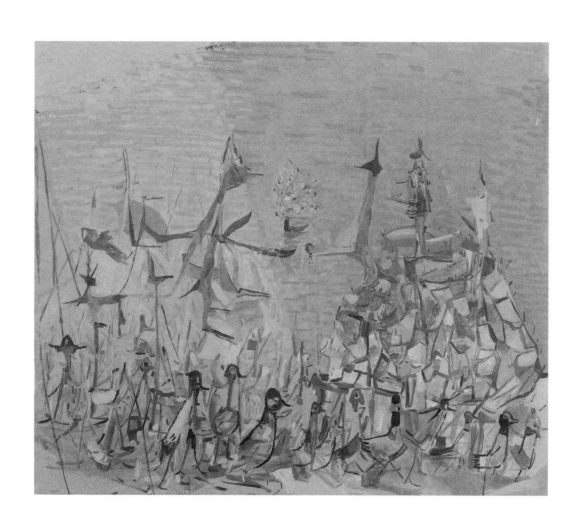

67

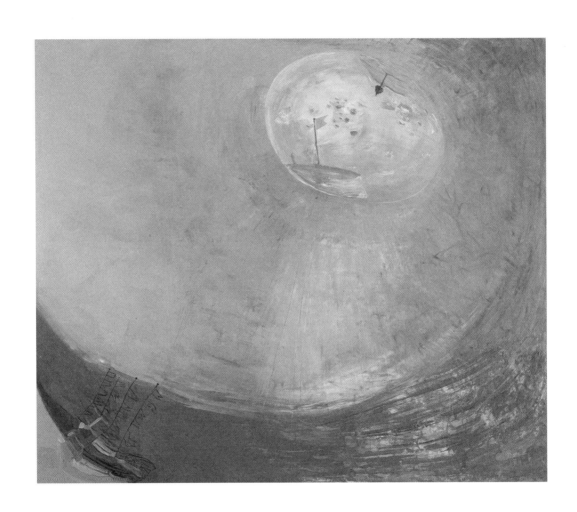

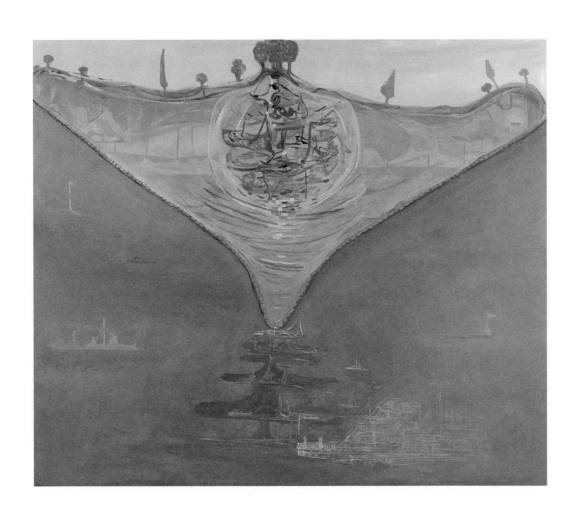

Janaina Tschäpe

Born 1973, Munich, Germany.
Lives and works in New York and Rio de Janeiro, Brazil.

Haunting, dreamlike narratives about nature, solitude, and the feminine body are at the heart of Janaina Tschäpe's works, which encompass photography, films, drawings, and installations. The German-Brazilian artist is particularly fascinated with the endless possibilities presented by the fluidity of nature's forms, be they found within the natural landscape or the human body as it moves through space and changes over time. Using her own body as a starting point, à la Cindy Sherman, Tschäpe plays with the possibilities of flesh by constructing photographs that work to dissolve differences between the body and the surrounding landscape.

Ana Mendieta's work of the 1970s provides a key artistic precedent for Tschäpe's elusive, body- and land-based performance photographs and films. In works such as the Silueta and Tree of Life series, Mendieta melded performance and body art with the natural sites of earth art, while also introducing feminist concerns. Like Mendieta, Tschäpe frequently uses her own body as a sculptural device. Employing handmade, homemade props and prosthetics fabricated from bands of colored rubber tubing and latex, Tschäpe attaches otherworldly "artificial limbs" to her head, arms, and legs, creating hybrid bodies that evoke a range of amphibian creatures, both real and imaginary. Wearing these costumes she poses within lush green forest settings, her face masked or turned away from the camera, her body semisubmerged in black, shimmering pools of water. Both

alluring and grotesque, the transparent, air and liquid-filled vessels evoke all manner of biomorphic forms: egg sacs and jellyfish, tumors and tuberous plant growths come to mind, as well as the body in various stages of gestation. In many of these photos the latex prosthetics appear to be growing out from Tschäpe's rooted figure and into the landscape itself.

In addition, Tschäpe creates drawings and paintings that continue her explorations of hybridized bodies and landscapes. She brings the swollen, globule-like forms directly onto the walls, sculpting hives of swirling activity out of thick, creamy layers of plasticine. Her drawings, such as *Inhanbunpungà* (2004), consist of similarly floating, biomorphic forms that, when seen at a distance, abstractly evoke mermaids, giant insects, or the rippling surface of water. A closer inspection of the surface reveals an underlying world in microcosm: bubbles floating within bubbles jostle against confetti-colored particles. This drawing is a triptych, with the edges of the frames butting up against each other so that it gives the impression of a landscape viewed through the glass of an aquarium. The flowing, flowery lines of the composition stream outwards, at points appearing to exceed the upper edges of the paper, which creates the appearance of something that has been trapped or contained—or of cellular material smeared on laboratory slides. Encompassing macro- and microcosmic views of the natural world, Tschäpe's paintings, performances, and photographs gently reinscribe a place for our bodies within it.

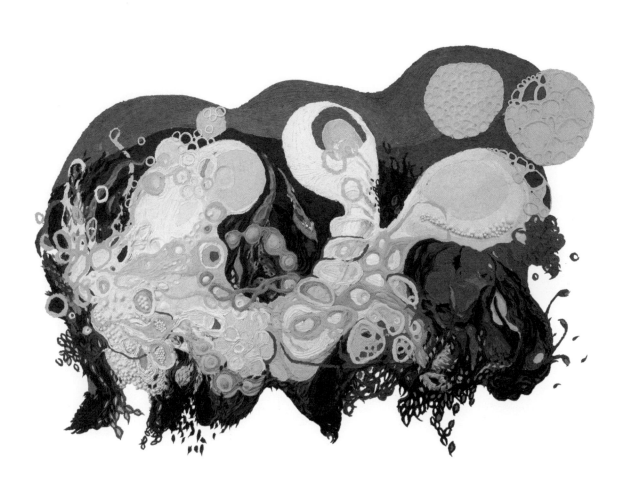

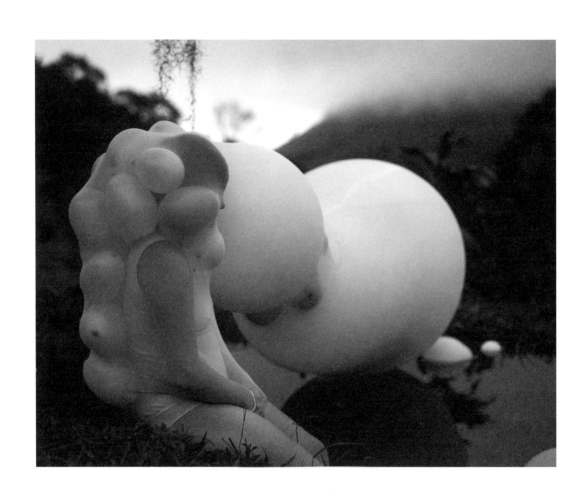

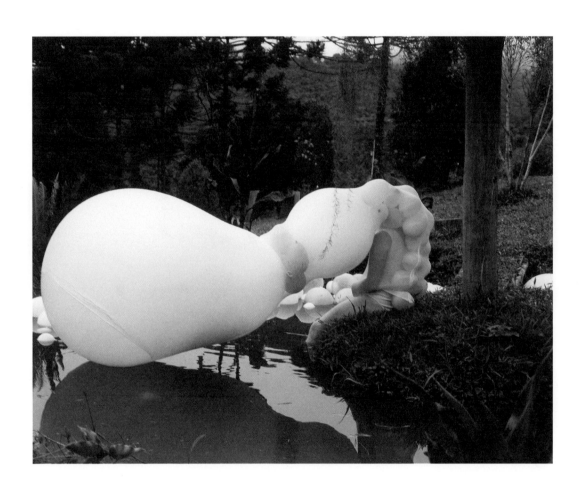

Checklist of the Exhibition

In dimensions, height precedes width precedes depth.

Rowena Dring

Tree, 2002
Stitched fabric
78¾ × 47¼ in. (200 × 120 cm)
Collection of Ramesh Chakrapani,
New York
(p. 23)

Untitled (Stream), 2002
Stitched fabric
86½ × 118 in. (220 × 300 cm)
Private collection,
Fort Worth, Texas
(p. 25)

Untitled (Water), 2002
Stitched fabric
31 × 59 in. (79 × 150 cm)
Collection of Jon Koplovitz,
New York
(p. 26)

Trees and Mountain, 2004
Stitched fabric
54¼ × 59⅛ in. (138 × 150 cm)
CAP Collection
(p. 24)

Pia Fries

Faso, 2000
Oil on wood panel
67 × 47 in. (170 × 120 cm)
Collection of Dave and Nancy Gill,
Columbus, Ohio
(p. 29)

Ruislip, 2001
Oil and screenprint on board
in two parts
(L) 31½ × 25¼ in. (80 × 64 cm)
(R) 31½ × 19⅝ in. (80 × 50 cm)
Courtesy CRG Gallery, New York

Caspian, 2001–2002
Oil and screenprint on panel
78¾ × 102⅜ in. (200 × 260 cm)
Rebecca and Alexander Stewart,
Seattle, Washington
(p. 27)

Les Aquarelles de Leningrad,
F Series, 2003
Collage and oil on wood
4 panels, each 31½ × 23⅝ in.
(80 × 60 cm)
Mr. and Mrs. C. Robert Kidder,
Columbus, Ohio
(p. 28)

Jason Gubbiotti

Green Piece, 2003
Oil on panel
20 × 22 × 2½ in.
(51 × 56 × 6 cm)
Collection of Ellen and Peter Safir
Courtesy of Fusebox,
Washington, D.C.
(p. 31)

Inferior Mechanics, 2003
Oil on canvas
26 × 32 × 6 in. (66 × 81 × 15 cm)
Collection of David Edmondson
Courtesy of Fusebox,
Washington, D.C.
(p. 32)

Park, 2003
Gouache, watercolor, and pen
on paper
15 × 22 in. (38 × 56 cm)
Collection of Anne Baldwin
and Michael Monti
Courtesy of Fusebox,
Washington, D.C.

Il Piccolo Diavolo, 2003–2004
Oil on wood panel
24 × 24 in. (61 × 61 cm)
(surface area)
Collection of Andres Tremols
and Michael Reamy
Courtesy of Fusebox,
Washington, D.C.
(p. 33)

Jim Hodges

Angels Voices, 1993
Silver plate jewelry chain
37 × 36 in. (94 × 91 cm)
Collection of Janice and
Mickey Cartin
(p. 36)

From Our Side, 1995
Silk flowers with thread
120 × 120 × 3 in.
(305 × 305 × 8 cm)
Collections of Eileen
Harris-Norton and Peter Norton,
Santa Monica
(p. 35)

Endlessly, 2002
Portfolio of 14 C-Prints
Dimensions variable
Ron and Ann Pizzuti,
Columbus, Ohio
(p. 37)

Oh Great Terrain, 2003
Latex paint
Dimensions variable
Courtesy the artist, CRG Gallery,
and Stephen Friedman Gallery

David Korty

Untitled (Garbage on a Hillside),
2003
Acrylic and colored pencil
on canvas
72 × 72 in. (183 × 183 cm)
Collection Van Valen,
New York/Amsterdam
(p. 39)

Untitled (Houses on a Hill), 2003
Acrylic and colored pencil
on canvas
57 × 89 in. (145 × 226 cm)
Private collection, New York
(p. 40)

*Untitled (Mexico Park/Figures
Walking Beneath Trees)*, 2003
Acrylic and colored pencil
on canvas
72 × 72 in. (183 × 183 cm)
Sender Collection
ADSFA 04.0007
(p. 41)

Kori Newkirk

Solon 6:12, 2000
Plastic pony beads, synthetic
hair, and aluminum
83 × 73 in. (211 × 185 cm)
Collection of Dean Valentine
and Amy Adelson, Los Angeles
(p. 44)

Stutter, 2002
Plastic pony beads, synthetic
hair, and aluminum
48 × 48 in. (122 × 122 cm)
Sprint Corporation Art Collection,
Overland Park, Kansas
(p. 45)

Bam Bam, 2003
Plastic pony beads, synthetic
hair, and aluminum
91 × 60 in. (231 × 152 cm)
Courtesy of The Project,
New York and Los Angeles

LK-3, 2004
Plastic pony beads, synthetic
hair, and aluminum
90½ × 84 in. (230 × 213 cm)
Lindemann Collection,
Miami Beach
Courtesy of The Project,
New York and Los Angeles
(p. 43)

Katie Pratt

Purling, 2002
Oil on canvas
57 × 39 in. (145 × 99 cm)
Courtesy of Kontainer Gallery,
Los Angeles

Rot-Weiler, 2002
Oil on canvas
78 × 71 in. (198 × 180 cm)
Courtesy of Kontainer Gallery,
Los Angeles

The Screedings, 2002
Acrylic and oil on canvas
12 × 10 × 3 in. (30 × 25 × 8 cm)
Courtesy of Kontainer Gallery,
Los Angeles
(p. 49)

Spin-Edge, 2002
Oil on canvas
78¾ × 86⅝ in. (200 × 220 cm)
Courtesy of Kontainer Gallery,
Los Angeles
(p. 48)

Finisterre, 2003
Acrylic and oil on canvas
12 × 10 × 3 in. (30 × 25 × 8 cm)
Courtesy of Kontainer Gallery,
Los Angeles
(p. 47)

Michael Raedecker

drift, 1999
Acrylic and thread on linen
66 × 96 × 1⅜ in.
(168 × 244 × 3.5 cm)
Rubell Family Collection, Miami
(p. 52)

blind spot, 2000
Acrylic and thread on canvas
46⅛ × 34 in. (117 × 86 cm)
Collection of Dean Valentine
and Amy Adelson, Los Angeles
(p. 51)

is this it, 2001
Acrylic and thread on canvas
60¼ × 40⅜ in.
(153 × 102.5 cm)
Marc and Livia Strauss Family
Collection, Chappaqua, New York
(p. 53)

Neal Rock

*Work from the Polari Range,
CJ/32*, 2004
Pigmented silicone with
mixed media
110 × 96 × 14 in.
(279 × 244 × 36 cm)
Courtesy of Henry Urbach
Architecture, New York
(p. 55)

*Work from the Polari Range,
CL/24*, 2004
Pigmented silicone with
mixed media
22 × 15 × 9 in. (56 × 38 × 23 cm)
Collection Steve Shane, New York
Courtesy of Henry Urbach
Architecture, New York
(p. 57)

*Work from the Polari Range,
DG/40*, 2004
Pigmented silicone with
mixed media
45 × 98 × 14 in.
(114 × 249 × 36 cm)
Courtesy of Henry Urbach
Architecture, New York
(p. 56)

Lisa Sanditz

*Dolly Parton's Peaks,
Knoxville TN*, 2003
Oil on canvas
56 × 68 in. (142 × 173 cm)
Susan Hancock and Ray Otis,
Winter Park, Florida
(p. 60)

*49th and Clarke Street Park,
Oakland, California*, 2003
Mixed media on canvas
46 × 64 in. (117 × 163 cm)
Rebecca and Alexander Stewart,
Seattle, Washington
(p. 59)

*If you didn't know the Swiss Alps you
might believe you're there*, 2003
Oil on canvas
72 × 68 in. (183 × 173 cm)
Francie Bishop Good, Ft.
Lauderdale, Florida

Surfing the Arctic Circle, 2003
Mixed media on canvas
46 × 64 in. (117 × 163 cm)
Ron and Ann Pizzuti,
Columbus, Ohio
(p. 61)

Ranjani Shettar

Vasanta, 2004
Pigments and handrolled wax,
strings dyed in tea
120 × 288 × 156 in.
(305 × 732 × 396 cm)
Courtesy of Talwar Gallery,
New York
(pp. 63–65)

Amy Sillman

Columbus Day, 2001
Oil on canvas
60 × 72 in. (152 × 183 cm)
Jennifer McSweeney and
Peter Reuss
(p. 68)

Valentine's Day, 2001
Oil on canvas
60 × 72 in. (152 × 183 cm)
The Baltimore Museum of Art:
Purchased in Honor of Elaine B.
Snyder with funds contributed
by her Family and Friends
(BMA 2001.348)
(p. 69)

Hamlet, 2001–2002
Oil on canvas
72 × 84 × 1 ½ in.
(182.9 × 213.4 × 3.2 cm)
Whitney Museum of American
Art, New York; Purchase, with
funds from the Contemporary
Committee, 2003.306

The Egyptians, 2003
Oil on canvas
72 × 84 in. (183 × 213 cm)
Collection of the artist
Courtesy of Brent Sikkema,
New York
(p. 67)

Janaina Tschäpe

Inhanbunpungà, 2004
Mixed media on paper
Triptych: 30¼ x 22½ in.
(77 x 57 cm) each
Courtesy of Brent Sikkema,
New York

Juju 1, 2004
Cibachrome print
40 x 50 in. (102 x 127 cm)
Courtesy of Brent Sikkema,
New York
(p. 72)

Juju 4, 2004
Cibachrome print
40 x 50 in. (102 x 127 cm)
Courtesy of Brent Sikkema,
New York
(p. 73)

Untitled, 2004
Plasticine on wall
120 x 180 in. (305 x 457 cm)
Courtesy of Brent Sikkema,
New York
(p. 71)

Acknowledgments

As ever, this exhibition and publication could never have been brought to fruition without the hard work of everyone at the Wexner Center. Labor seen and unseen deserves gratitude. Thank you. Special thanks are due to Dr. Katherine Whitlock for her humorous and perfect curatorial assistance, to Claudine Isé whose entries give this volume a breath of fresh air, to Megan Cavanaugh Novak for expertly moving me through space so I could see all the work and dream up the exhibition, and then for picking up where Katie left off, to Jill Davis for cheerleading and deftly managing the exhibition tour, and to Sherri Geldin for her suggestions and support.

Our following friends helped us locate the works and secure the loans for the show: Susanna Greeves and Renee Reyes, Andrea Rosen Gallery, New York; Emma Robertson, The Approach, London; Teka Selman and Ellie Bronson, Brent Sikkema Gallery, New York; Stacy Fertig, Christopher Grimes Gallery, Santa Monica; Carla Chammas and Brian Monte, CRG Gallery, New York; Elizabeth Dee, Joseph Wolin, and Ryan Steadman, Elizabeth Dee Gallery, New York; Sarah Finlay and Patrick Murcia, Fusebox, Washington, D.C.; Philip Nelson and Cécile Barrault, Galerie Nelson, Paris; Carol Greene, Greene Naftali, New York; Henry Urbach, Jeffrey Walkowiak, and Craig Buckely, Henry Urbach Architecture, New York; Mihai Nicodim, Kontainer Gallery, Los Angeles; Simon Preston and Jeffrey Uslip, The Project, New York; and Deepak Talwar, Talwar Gallery, New York. A very special thank you is due to all of the lenders for sharing their wonderful objects with viewers in Ohio, Texas, and California.

Thanks to Susan Dackerman, whose skepticism I have come to rely on greatly, and to Liz and Eliot Bank, Nancy and Dave Gill, Mary Kidder, Jan and Ben Maiden, and Joyce and Chuck Shenk whose exuberant company in Miami fashioned the decorative backdrop against which this exhibition was born.

Helen Molesworth

Photo Credits

In addition to the individuals and institutions listed in the captions and the Checklist of the Exhibition, the following credits apply to some of the images reproduced in this catalogue.

Photo courtesy of The Approach, London, p. 52. Photo: Hans Brändli, courtesy of Christopher Grimes Gallery, Santa Monica, California, p. 29. Photo: Hans Brändli, courtesy Galerie Nelson, Paris, p. 28. © Condé Nast Archive/CORBIS, p. 7. Photo courtesy of CRG Gallery, New York, pp. 27, 35, 37, and 59–61. Photo courtesy of Elizabeth Dee Gallery, p. 24–25. © 2005 The Willem de Kooning Foundation / Artists Rights Society (ARS), New York, p. 15. Photo: Rick Gardner, Houston, p. 15. Photo courtesy Greene Naftali, pp. 39–40. Photo: © Erich Lessing / Art Resource, New York, pp. 8 and 12. © Douglas M. Parker Studio, p. 16. Photo: Tom Powell, courtesy of Elizabeth Dee Gallery, p. 23. Photo courtesy of The Project, New York and Los Angeles, p. 44. Photo courtesy of Andrea Rosen Gallery, New York, © Michael Raedecker, pp. 51 and 53. Reproduction courtesy of Miriam Schapiro and Kristen Frederickson Contemporary Art, New York, p. 19. Photo courtesy of Brent Sikkema, New York, p. 68–69. Photo: Oren Slor, courtesy Greene Naftali Gallery, p. 41.

Colophon

Printed by Pressworks, Plain City, Ohio, and bound by Bind Tech, Nashville, Tennessee. Text pages printed on Finch Soft White Fine Finish, 100# Text paper. Typefaces used are Joanna, Gill Sans, and Gill Sans Condensed, all designed by Eric Gill.